THORNBURY
PUBS

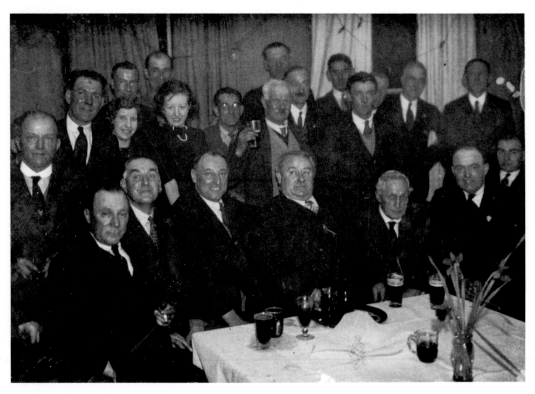

The self styled 'Boozers labourers' or to give them their correct title The Thornbury and District Licensed Victuallers at a get together sometime in the 1930s.

THORNBURY
PUBS

GEORGE FORD

AMBERLEY

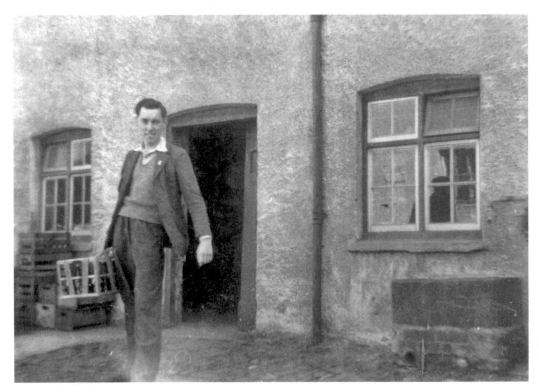

The author in his teens helping out at his father's pub.

First published 2010

Amberley Publishing Plc
Cirencester Road, Chalford,
Stroud, Gloucestershire, GL6 8PE

www.amberley-books.com

British Library Cataloguing in Publication Data.
A catalogue record for this book is available from the British Library.

ISBN 978 1 84868 910 7

Typesetting and Origination by Amberley Publishing.
Printed in Great Britain.

CONTENTS

INTRODUCTION

Public House, Inns, or just plain pubs — call them what you may, these establishments have been part of the social life of towns and cities throughout Britain since early times. They are a significant part of our heritage and deeply rooted in our way of life, being a focal point to bring people together for socialising, celebrating or to drown their sorrows. Today, Thornbury has nine pubs within the area bounded by the High Street and Castle Street to the west, Midland Way to the south and the sweep of Morton Way to the east and north. Over the years, there has been a total of thirty-four outlets for the sale of beer within this area — when one closed another would open in a different location, so the total does not reflect the drinking habits of past generations of Thornburians. The maximum number open at any one time was seventeen immediately after the Beerhouse Act of 1830, but the number quickly reduced to twelve, which again was a significant number when considering the then population of the town. The retention of its cattle market can be attributed to Thornbury keeping a higher number of outlets when compared to places like Berkeley and Wickwar, which, in the past, were of similar size to Thornbury but which declined once they lost their markets.

Many of the bygone pubs in Thornbury have been demolished and the sites redeveloped, while other old pub buildings are still standing and being used for a variety of purposes, such as offices, private houses, a shop and a café. The further back in time, the fewer records there are of these bygone pubs, or beerhouses as they were originally known. Where information is available, the amount varies between pubs but all were subject to the same influences, which have shaped pub life and development over the years. From the early years, when beerhouses were open around the clock to everyone, they progressed through periods of reduced opening times only for this trend to be reversed until today the modern pubs can again open twenty-four hours a day if desired. Pubs have also lost their previous status as being a predominantly male preserve and are now open again to all the family.

Recently, the media has been active in emphasising the 'booze culture' in today's society, but it has been found whilst researching this book that this is not a recent phenomenon and has existed in Britain for centuries, with Thornbury being no worse than any other place of comparable size. One pleasing aspect of Thornbury pubs is their retention of what may be considered traditional pub names. In recent years, what was the Exchange was renamed the Knot of Rope, an acceptable change, seeing that it referred to the emblem of the Stafford family who owned Thornbury Castle for 400 years. Whilst in 1997, Whitbreads, the brewers and owners of the Barrel, proposed to re-brand it and give it a trendy new name of Ebenezer Riley's Coaching House. This

name, being unrealistic and not appropriate for a pub in a rural town, was opposed by the pub's customers and the Town Council, which persuaded the brewers to drop their proposal, so conformity prevailed.

Thornbury pubs are a mixture of the old and the new, five of the nine being in listed buildings, with the older ones having undergone various degrees of internal refurbishment to satisfy most tastes and so are well suited to carry on providing refreshments for the townsfolk and others well into the future.

BIBLIOGRAPHY

Brandwood, Geoff, Davison, Andrew and Slaughter, Michael, *Licensed to Sell*
Caffell, W. A., *A Study in Local History Vol II*
Caffell, W. A., *A Study in Local History Vol III*
Census forms 1841 to 1901
Haydon, Peter, *Beer and Britannia*
Holpin, Ron, *Thornbury and District Skittles League*
Smith, A. H., *Place names of Gloucestershire Part 3*

ACKNOWLEDGEMENTS

The author would like to thank the following for their help in various forms, without whom this book would not have been possible.

Andy Bown, Bristol Reference Library, Chris and Sandra Doig, Tim Edgell, David Eveligh, Nick Fear, Gazette Newspapers, Staff at Gloucester Records Office, Tina Hampson, Liz Hodsdon, Ron Holpin, Roger Howell, Rosemary King, Milburys Estate Agents, Heather Palmer, Pints West paper, Nigel Pitcher, Robert Powell and Meg Wise.

The author would also like to thank Thornbury and District Heritage Trust for allowing him to use photographs held in the archives at Thornbury Museum. Where it has been impossible to trace the origintor of photographs they have been used with no intention of breeching the originators copyright entitlement to due recognition.

ONE

THE EVOLUTION OF
THORNBURY PUBS

The Early Years

Among the many skills the Romans brought to Britain were those of road building and brewing. At various points along the roads, which linked settlements, the Romans built an early form of wayside inn where ale was brewed and sold. When the Romans left, brewing lapsed into a rather fragmented activity, which was carried on by the Britons, who had been Romanised, but was gradually brought together and done on a communal basis usually under the auspices of the Church. This link between the Church and brewing can still be found in many villages today where there is a pub near the church. Although today there is no pub near Thornbury church, a 'bruerne' or brewhouse is recorded as being situated on the site of the entrance to the present-day Warwick Place at the bottom of Castle Street near the vicarage, indicating the possible involvement of the town's church in brewing.

Communal brewing began to die out around the thirteenth century when permanent alehouses, which brewed their own ale, began to appear. As most water supplies were generally contaminated, brewing was a necessary part of life, ale being drunk, in various strengths, by all the population, men women and children. There was no cheap alternative until tea was introduced much later, at the end of the eighteenth century, wine being much too expensive.

Alehouses continued their development into the fourteenth century when they first began to be named. The earliest records of named inns in Thornbury are the Heronceau in 1474 and the Crookhorne in 1580, but the exact location of these is uncertain. Other early inns whose locations are known are the Antelope, Swan and Widows Mantle. These take their names from emblems of the coat of arms of the Duke of Buckingham who, between 1511 and 1521, was building Thornbury Castle. [1]

1 The naming of inns followed no set pattern and were usually decided upon by the owner. Later re-naming occurred when the owner or licensee changed.

The sixteenth-century alehouses provided the only places of warmth for meeting and socialising, where drinks were served in the standard quart (two pint) pots. At that time, there was no social stigma in being drunk, but those who transgressed to extreme could be placed in the stocks for six hours or — as an entry in the Consistory Court Records of 9 October 1551 shows in reference to Walter Gibbes and William Crosse of Thornbury — had to declare in the parish church their penitence for being 'great drunkards'. Also, during the sixteenth century, a gradual distinction between alehouses and inns began to appear. Alehouses were basically domestic buildings that were thrown open for people to drink in the kitchen or parlour and where the brewing was done at the back of the premises. Inns, however, bought their ale and provided food and lodgings to travellers, and, as such, considered themselves socially superior to alehouses.

When the road network was improved for wheeled traffic, the trade of inns improved significantly. This was further enhanced when mail coaches started to run in the eighteenth century and led to certain inns becoming designated stops. In Thornbury, the Swan became the mail coach stopping point and, as such, enhanced the position of the licensee. He was now accountable for receiving and despatching the mail; as this required a man of good character, he also became the local tax collector who was responsible for collecting the license fees from trades people in the town. To show the status of the Swan against other inns, when it was mentioned in old documents and trade directories, its name was succeeded by 'Postage and Excise'. (A transcript of a 1796 document showing the various trades from which the licensee of the Swan collected excise fees is given in appendix 1). Other inns did not miss out on the increase in wheeled traffic, and some became depots or collecting points for local carriers. One bygone pub, The George, was the starting point for a flying coach service to Bristol, flying coaches being the predecessors of mail coaches.

Brewing

Those establishments that did not brew their own ale relied on the local commercial or common brewer and bought in their supplies, whilst others, mainly the alehouses, bought the malted barley from a maltster and did the brewing themselves. The brewing process has remained basically the same throughout the centuries and can be divided into two separate operations: malting and the actual brewing. The preliminary process of malting using barley grain consists of helping the grain to germinate by soaking it in water for about two days, then allowing it to ferment whilst turning it regularly. Once the grain has acquired a sweet taste, any further growth is destroyed by spreading it on the floor of a kiln and thoroughly drying it. The malt is now ready to be crushed and ground in a mill before being used for brewing. This requires the malt to be again soaked in water and then boiled in a suitable vessel before the resultant liquor is filtered off. This process was repeated two or three times using the same malt or mash to extract the maximum

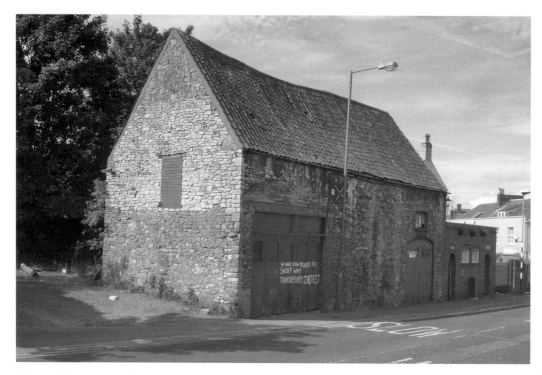

The Malthouse in Quaker Lane opposite the Plough, which was owned by Abraham Cole in 1841.

amount of alcohol. The first brew from each mash was known as strong ale, while the second and third brew, being weaker, were known as small, or breakfast, ale.

In the early days, as brewing was basically a boiling process, this work was carried out by women. If they produced a brew that was not passed by the local ale tester as being 'goode for men's bellies' they could look forward to a seat in the ducking stool as a punishment.

Ale produced by this early method had one disadvantage in that it did not keep well. This was overcome by introducing hops into the brewing process, which helped preserve it and gave it flavouring. [2] Hops were first used in Britain in the sixteenth century but some rural areas did not use them until the eighteenth century. When the brewers in Thornbury first used hops is not known.

Records and deeds relating to the older established pubs, both past and present, in Thornbury refer to 'brewhouses', indicating that at one time they brewed their own ale. There were at least two malt houses in the town, one in the building opposite the Plough and another earlier one in Castle Street, which stood where Nos 40 and 42 were later

2 The term "ale" should correctly be used to describe the brewing product from malt and yeast alone, whereas the name "beer" originally referred to the product when hops are added to the process. Today both terms are interchangeable in their usage, and have ceased to have a precise meaning.

built. The malt from these is believed to have been ground and crushed in a mill, which stood where No. 5 Saw Mill Lane is now situated. This mill building, before demolition, was occupied by Till's Transport and later, Ebley Tyres. The only commercial brewery in Thornbury was in Rock Street, which was operated by James Sly. When it started is not known, but the autumn of 1851 is on record as being dry, with many of the town's wells and cisterns running dry. As these were the brewery's only source of water, this may be the reason for it to cease operating.

The two categories of brewers in the town, commercial and individual brewhouses, were supplied with the necessary barrels by two coopers, one in St Mary Street near the rear entrance to the Swan and the other in Castle Street opposite the Chantry.

Early Government Legislation

As government legislation emanated from London, the laws passed contained the terminology used in its surrounding area. The term 'beerhouse' now came into common usage to cover those establishments which only sold beer and which had previously been known in the rest of the country as alehouses. The name 'inn' remained to describe places that sold beer and spirits and also provided food.

Brewing had been the nation's largest industry since the sixteenth century, so it is not surprising that the government saw it as a source of revenue. The tax on beer in 1688 was 2s 6d (12½ p) per barrel, and later, in 1763, the tax on the other rural drink, cider, was raised from 4s to 10s (50p) per hogshead. The government also began to legislate more on the running of inns and beerhouses; the Licensing Acts of 1729 and 1753 required all inns and beerhouses to be registered annually at Brewster Sessions. Prior to this, all that was required was consent from the local JPs and a pledge ensuring good behaviour on the premises. Other Acts affected the layout of inns, in that those that sold spirits were to provide a separate partitioned-off area. This led to purpose-built inns being constructed with the required two drinking rooms, which later evolved into the public and saloon bars.

In the late eighteenth century, the financial outlay to meet these conditions were beyond some inn owners, so the more prosperous brewers began to buy these inns and install their own retainers, thus starting the system of 'tied' houses, although these did not start to appear in Thornbury until the mid-nineteenth century. Then, some of the town's inns and beerhouses began to be supplied from breweries in Minchinhampton, Wotton under Edge and Wickwar as well as several breweries from Bristol.

For centuries, England has been either trading with or at war with the countries of the near continent, with returning traders and soldiers having acquired a taste for a new drink — gin. This was either imported or distilled at home, and its popularity grew until it outsold beer in many cities and large towns. Its cheapness led to widespread debauchery and drunkenness, which was best illustrated by Hogarth in his sketch of Gin

Rock Street as seen from the corner of the United Reformed church before demolition was completed showing the location of the brewery (arrowed) operated by James Sly in the 1840s.

Lane. This situation may seem irrelevant to a small market town like Thornbury, where gin sales did not cause a problem, but the remedial legislation passed by the government had a profound effect.

To encourage the population to switch from gin to beer, which was judged to be a healthier drink, the government passed the 1830 Beerhouse Act. This allowed any householder to sell beer, ale and cider (but not wines) after purchasing a two guinea (£2.10) licence. Although the Act was aimed at the cities and large towns, it was made nationwide with the effect that the number of beer outlets almost doubled within a year and enabled some of the previous unlicensed beer and alehouses that had evaded the 1753 Act to become licensed. Around 1800, there were, in Thornbury, six inns and an unknown number of beerhouses. After 1830, there were, in total, seventeen licensed premises for the sale of beer. This number fell over the next ten years as the government saw the flaws in the Act and amended it, in 1834, by raising the licence fee to three guineas and requiring the licensee to have a certificate of good character. It was again amended in 1840 when the rateable value of the premises had to be £8. The outcome of these two amendments was the appearance of the first off licences. One other contributing factor to the fall in the number of outlets in Thornbury could be that the market was saturated for the available consumers.

Further government legislation affecting inns and beerhouses came in 1869 with the Wine and Beerhouse Act. This brought them under the control of the local magistrates and also took away the task of collecting licence fees from the 'Excise' inns. For many years, JPs, under pressure from anti-drink campaigners, had refused to issue licences for new premises, and this was now carried on by the magistrates. From this arose the practice of inn owners transferring licences from one site to another, either to get more trade or because the original building was becoming dilapidated or unsuitable. Examples in Thornbury are the relocation of the original Lamb from near the church to the centre of the High Street and the transfer of the licence from the second Beaufort to Michael's. Another Act, the 1872 Intoxicating Liqueur Bill, increased the fines for drinking offences, prohibited under-sixteens from drinking and made the local police responsible for appointing inspectors of licensed premises. This latter duty was later carried out by the police themselves. The 1872 Act also required licensees to display their name over the door to their premises.

The Arrival of the Railway

The construction of the railway to Thornbury, which opened in 1872, had a great impact on the town. Laying a railway with its embankments, cuttings and buildings was very labour intensive, and the many tradesmen and navvies brought extra trade to the inns and beerhouses of the town. All the available accommodation in lodging houses and inns was taken up. The 1871 census shows that the original Wheatsheaf housed ten lodgers in addition to the licensee and his family. To cope with this influx, the magistrates transferred a licence to the Bathings at the bottom of Bath Road. It was known as the Bathin Place and had ceased trading by 1874. Once the railway was in operation it allowed beer to be brought to Thornbury from places such as Burton on Trent and later from Shepton Mallet. It also allowed the wine and spirit merchant James Michael, who occupied the premises now known as the Knot of Rope, to expand his business into the bottling of ales and stout, which he sold through his off licence. The supply of beer by rail continued into the twentieth century and ceased in the mid-1950s, although by that time it was delivered by lorry from Yate Station.

A Family Business

From the mid to late nineteenth century, the comparatively large number of beerhouses in Thornbury — when considering the then population of the town meant that the income from beer sales alone was insufficient for most licensees to be able to support

JAMES M. MICHAEL.

ALE & PORTER DEALER
THORNBURY.

AGENT FOR

ALLSOPP AND SON'S
CELEBRATED

EAST INDIA PALE & BURTON ALES
E. HARRIS & CO.'S
Wiltshire Beer & Ales,

Guinness's and Mander's

DUBLIN STOUT.

Ale and Stout in 9 Gallon Casks.

ALL ORDERS PROMPTLY ATTENDED TO.

PRICES ON APPLICATION.

An advertisement from an 1877 trade directory showing how after the railway to Thornbury opened in 1872 James Michael was able to bring to the town and sell beer from distant breweries. Note that one brewer still differentiated between beer and ale.

their families. This resulted in them having a second occupation, and if this took them away from the premises, wives or other family members were left to attend to the customers. An example of beerhouse income can be illustrated by an extract from the accounts of the brewers Arnold and Perrett who, in 1890, supplied beer with a wholesale value of £165 17s 3d to the Porter Stores. Even with a profit margin of 10%, this only gave a weekly income of about 7s, which was below the wages received by an agricultural labourer. The second, or in some cases primary, occupation of licensees covered a wide range of work, as shown in Appendix 2.

With the running of a pub during the day being left to family members, they learned the trade and were ideally suited to step up and take over the licence should the licensee die or decide to retire. This gave rise to pub-owning or pub-running dynasties, which were common throughout Britain up to the early twentieth century. In Thornbury, between the years 1841 and 1906, various members of the Cullimore family had their 'name over the door' at the Horseshoe, Plough, Black Horse, Royal George and Crispin, while the Hall family owned and ran the White Lion between 1870 and 1915.

Magistrates appear to have had no qualms in granting licences to widows of licensees within the town of Thornbury, but further afield it was different. At a Petty Sessions sitting in November 1902, they refused to transfer the licence from the late Alfred Dyer of the Fox at Oldown to his widow, Rhoda, on the grounds that the inn was too far from a police station should she ever require to summon help.

The Late Victorian and Edwardian Era

This period is noted for a gradual drop in the number of pubs throughout the country. It started in the decade of the 1880s when there was a downturn in the country's economy. To counter this, the government imposed a rate revision on all licensed premises and increased the duty on beer — this at a time when 43% of government revenue came from drink. The effect of these measures was to force many marginally viable pubs to close. In Thornbury, those that are believed to have ceased trading as a result of this were the Black Lion and Seven Stars.

Two Licensing Acts, in 1902 and 1904, followed by the Licensing Consolidation Act of 1910, again reduced the number of pubs. These Acts allowed local magistrates, who were under pressure from the Temperance movement, to close down pubs considered superfluous to requirements. A levy was imposed on all licensed premises and the proceeds used to compensate those that were closed down. The Horseshoe was the only Thornbury pub to close as a result of this legalisation. With this drop in the number of licensed premises, trade in the remainder increased, lessening the requirement for their licensees to have a second income.

Some other clauses of the Licensing Acts are worth mentioning. Firstly, the 1902 Act made drunkenness in a public place an offence for the first time and secondly, the 1904

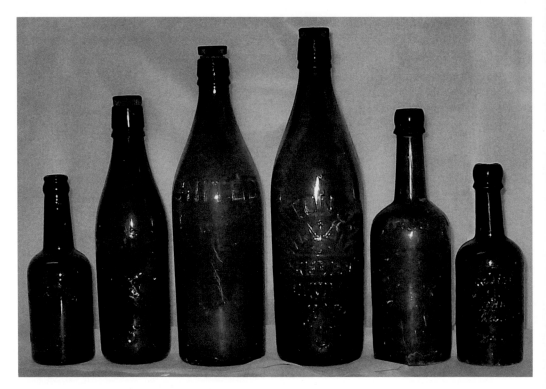

A selection of the type and shape of the bottles used by the various breweries in Bristol c. 1900 to supply their public houses. These include: second from left, W. J. Rogers Ltd of Jacob Street, Old Market, which supplied the Royal George; Centre, Ashton Gate Brewery, which supplied the Royal Exchange; and, far right, United Breweries of Lewins Mead, which supplied the Plough. The bottles for these three brewers were all manufactured in Bristol by Powell and Ricketts.

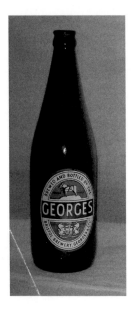

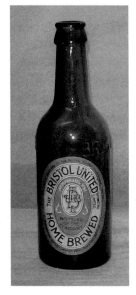

By the 1950s, after a series of amalgamations and take-overs, the number of brewers in Bristol had shrunk to two, Georges and Bristol United, with a corresponding reduction in the style and shape of bottles used. A half pint version of the bottle on the left was also used, and all came in wooden (later aluminium) crates of twenty-four bottles. Licensees were required to return all empty bottles to the brewery where they were washed, sterilised and reused. When bottles were sold as off sales, a penny was usually added to the price, which was refunded when the bottle was returned.

Act required licensees to submit to the police a plan of all rooms in their premises that were available to the public. The doors to these rooms also had to be numbered, e.g. public bar 1, smoke room 2, etc. This was to enable the police, when they made their routine checks, to know how many rooms to visit. In the times before betting shops came into being, these routine checks invariably took place a day or two before a big horse race, either the Grand National or Derby. As it was, and still is, illegal to write betting slips on licensed premises, these visits were also an attempt to catch the bookies' runner taking bets.

It was during the late Victorian era that the pub-goers of Thornbury had the widest choice of beers from no fewer than eight different breweries (see Appendix 3). This number would fall following a spate of mergers and take-overs during the depressed trading times of the 1930s.

Opening Times

The widespread drunkenness in early years could be attributed to there being no restrictions on the hours that inns and beerhouses could remain open. It was not until the 1828 Licensing Act was passed that the first restriction was imposed and pubs had to close during Divine Service on a Sunday. This was later extended by another Act in 1848, when they had to close between midnight on Saturday and noon on Sunday. Weekday hours were not affected until the 1872 Intoxicating Liquor Licensing Bill, when opening hours were set at 5 a.m. till midnight. The 1848 and 1872 Acts remained in force until the First World War, when, in 1915, the government banned all pubs from opening before 9 a.m. and made them close at 10 p.m. — the previous opening times being deemed detrimental to the war effort.

Opening hours were again limited by the 1921 Licensing Act, when opening times were set at eight hours a day during the week and five hours on Sunday. The Act gave the guidelines of opening to be not earlier than 9 a.m. and ending not later than 10.30 p.m. on weekdays. For Sundays the times were two hours between noon and 3 p.m. and three hours between 6 p.m. and 10 p.m., with Christmas Day and Good Friday treated as Sundays. Local magistrates were left to set the exact opening hours for their area. The times set for Thornbury and district were:

Weekdays	10.30 a.m-2.00 p.m.
	6.00 p.m.-10.30 p.m.
Sundays	12 noon-2.00 p.m.
	7.00 pm-10.00 p.m.

There were, however, two exceptions in Thornbury, the Wheatsheaf and Exchange, which, due to their proximity to the cattle market, were allowed to adjust their hours

on market days by extending the afternoon opening. This was countered by shortening the evening opening times to stay within the eight hours a day limit.

These hours stayed the same till after the Second World War when, during British summer time, evening closing during the week could be extended to 11.00 p.m. This was not mandatory, and had to be applied for by each individual licensee each year, if they wanted it. The next change to opening times came in 1988 when pubs were permitted to open all day and again, more recently, when twenty-four-hour opening was allowed, so the wheel has turned full circle, back to what it was in the early days.

Not Only Beer Sales

Pubs and their predecessors have been used from earliest times as places where men could have a drink, socialise and meet others, progressing through the seventeenth century when they first became business places for settling accounts, to more modern times when food sales make them virtually licensed restaurants. Licensees have had various sidelines to selling beer, ranging from being postmaster and tax collector at the Swan to the assorted second occupations of others who needed to supplement their incomes. The pub buildings have also, in times gone by, been used for various purposes serving the community.

The Swan, being the pre-eminent pub in Thornbury, was used to hold property auctions and for meetings of the townsfolk, including meetings to discuss the possibility of having a railway to the town. When motor transport arrived, its outbuildings were used as a small repair garage, with the petrol pump at the St Mary Street rear entrance. Also, before radios were widely owned the results of Parliamentary Elections were announced from on the portico at the front entrance.

Before the town was connected to the railway in 1872, the White Lion was a stop for a horse bus, which ran between Oldbury and Patchway. It was also the depot for one of the local carriers, with other carriers using the White Hart, Royal George and Porter Stores, the latter being rebuilt in 1879 with stabling for four horses, especially for a carrier's use.

Up to the early part of the twentieth century, it was the normal practice for coroners to hold inquests into sudden deaths in the pub nearest to the scene of the death. Six of the town's pubs were used to hold inquests: the Anchor, Black Horse, Plough, Royal George, Swan and Wheatsheaf. The Anchor was even used as a temporary mortuary to hold the body of a female tramp, who was murdered at nearby Pit Pool in 1879.

The Second World War and After

The Second World War affected the pubs in Thornbury in several ways, not least the extra trade it generated from the military units based in the area. Soon after the outbreak of war, the extensive outbuildings attached to the Exchange were requisitioned to become the headquarters of a searchlight regiment. Then, in 1940, these buildings became the quartermasters' stores for the 6th Maritime Regiment.

Due to the high convoy shipping losses and the military demand for fuel, petrol rationing for civilian use was introduced in 1941. Zoning regulations were then introduced for brewery supplies, stipulating that pubs had to take their beer from the nearest brewery to reduce transport costs. This meant that the pubs supplied by the breweries at Cheltenham and Stroud changed to suppliers from Bristol. The Cheltenham pubs (Anchor and Barrel) took their beer from George's Brewery, while the Stroud pubs (Black Horse and Wheatsheaf) took their beer from Bristol United Breweries. This reduced the drinkers' choice to the products of one of the two Bristol breweries, as the remainder of the pubs in the town were already supplied by them. During this time, deliveries from George's Brewery were done by steam lorry and occasionally by horse-drawn drays. These supply arrangements lasted until late 1946 when the affected pubs reverted to their original suppliers.

Wartime conditions brought about the occasional disruption to brewing, and with the general increase in demand the beer supply to pubs was sometimes rationed, resulting in some occasionally running out. One occasion when most pubs were either drunk dry or ended up very low on stock was V.E. (Victory in Europe) night, with the police turning a blind eye to drinking after hours. The Barrel, for instance, had only a few dozen half-pint bottles of beer left the following morning.

After the war, pub life gradually got back to normal with the re-instating of inter-pub darts and skittles leagues, which involved all pubs in the town in one or both leagues. When the town's social life restarted, the pubs again took it in turns to provide and man the bar for dances in the Cossham Hall, and they also stocked and manned the beer tent for functions on the Mundy Playing Field.

Modern methods of brewing and the cost involved now began to force brewers into amalgamations and takeovers so that they could enlarge their number of outlets to stay viable. For the brewers supplying Thornbury pubs, this started in 1956 when Bristol United Brewery was taken over by George's, and two years later, in 1958, when Cheltenham and Stroud breweries combined to form West Country Breweries. Further changes occurred when larger national brewers came on the scene. In 1961, George's was taken over by Courage's; the following year, Whitbread took over West Country Breweries.

As the majority of pubs nationwide were now owned and supplied by a handful of large brewers, in an effort to improve drinker's choice, the Monopolies Commission eventually managed to get the brewers to sell some of their pubs. The brewers, seeing their hold on their outlets was being eroded, eventually decided to sell all their pubs and concentrate on brewing. So, we have the situation today, with the pub-owning companies completely separate from the brewers.

The only other post war events to affect Thornbury pubs were the introduction of fruit machines, as a result of the 1958 Gaming Act, and the closure of the Queens Head, also in 1958. George's Brewery closed this pub because its small size and falling sales made it uneconomical to refurbish.

Cider

Being in a rural area, cider was one of the main drinks drunk in Thornbury pubs. This was initially supplied by local farmers, who produced cider using empty wine and spirit barrels to store it. This practice drew the spirit residue from the wood of the barrel, making the cider more palatable. Like brewing beer, it soon became more commercially viable to produce cider in a greater volume at one location. In 1924, the Arnold and Perrett brewery in Wickwar closed when brewing was transferred to Cheltenham. The following year, after conversion, it reopened as the Wickwar Cider Company, supplying cider to the Thornbury pubs. Later, in 1938, it changed its name to the Gloucestershire Cider Company and stayed a separate entity until 1958, when Bulmers bought a controlling interest. The new owners gradually transferred all cider making to Hereford until the Wickwar site closed in 1969. Over that time, tastes for cider in general had changed; with most of the old cider drinkers gradually dying out, the draught cider trade in Thornbury faded away. It has, however, been replaced by keg cider, a much clearer brew, more in keeping with modern trends.

The rough cider, or scrumpy, was supplied in 36-gallon barrels, while sweet cider, for the ladies, was supplied in 9-gallon casks. On occasions, a much stronger cider, known as Kingston Black, was available, and this also came in 9-gallon casks. Regular cider drinkers always had their drink in china pint-mugs, as it was supposed to taste better than from glass mugs. During the winter months, these drinkers would sit around the pub bar fires and mull their cider by plunging a red-hot poker into it.

As scrumpy drinking was an acquired taste, its potency can be a shock to anyone not used to it. This situation became evident during the Second World War, when servicemen stationed in the area sampled it. Their conduct, after trying to keep pace with the locals, forced the town's licensees to impose a two-pint limit on them.

Like beer, cider has not evaded the claws of the taxman. The initial tax of 4s per hogshead, which was imposed in the seventeenth century, was, per volume, on a par with the tax on beer. Later, in 1763, the cider tax more than doubled to 10s per hogshead and, at that stage, exceeded the beer tax. Later, the beer tax was gradually increased at a greater amount than the increase in cider tax; today, beer tax again exceeds that of cider.

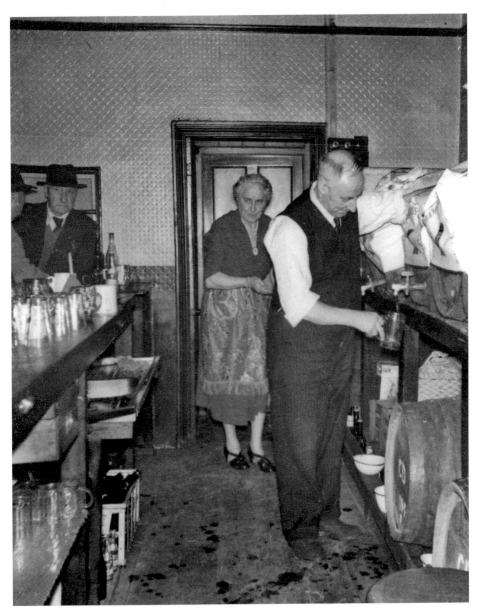

Beer and cider from the wood. Behind the bar at the Barrel in 1956. The beer in 18-gallon kilderkins and cider in 36 gallon barrels were positioned on the stout wooden frame called a tram and allowed to settle for twenty-four hours before tapping and spiling. Brass taps were used for beer and wooden ones for cider, the seal being made by wrapping brown paper around the shank of the tap.

Drinks to Suit all Tastes

When pubs were tied to one supplier, the range of drinks available to customers was somewhat restricted. Some pubs had only one draught beer and a choice of perhaps four or five bottled beers plus cider, which was either draught or bottled.

When this selection did not suit individual palates, a range of mixed drinks appeared. How these were arrived at is uncertain, either by experiment or accident, but all were dispensed in a pint glass or mug. Some of the more common were:

Shandy	A half pint of beer or cider topped up with lemonade
Tops	A pint glass filled with beer or cider to within about half an inch of the top then lemonade added to give a full pint
Half and Half	Half-pint bottle of beer mixed with half pint of draught beer
Brown Split	Half-pint bottle of brown ale mixed with half pint of draught beer
Light Split	As above using a bottle of light ale
Home Brew Split	Only drunk in pubs supplied by George's Brewery using a bottle of their prize winning Home Brew Ale mixed with half pint of draught beer
Black and Tan	Half-pint bottle of Guinness mixed with half pint of draught beer. (This drink must have been akin to porter)

Pubs that originated as beerhouses were, up to the early 1950s, only licensed to sell beer and cider, with the only concession to female drinkers being bottled beers and sweet cider. The licences of these ex-beerhouses were then extended to allow wines to be sold, so port and sherry became available. At the same time, bottled drinks, such as Babycham and Pony, aimed specifically at female drinkers, began to appear. The choice of drinks increased, especially when lager was introduced and spirit licences granted to all pubs. Now, all pubs have a large assembly of pumps on the bar and a multitude of bottled drinks, both chilled and unchilled.

From Crisps to Cajun Chicken Skewers

From the sixteenth century, inns had provided food and lodgings to travellers, as opposed to beerhouses, which were houses purely for drinking. The fare that inns could offer was extended in the eighteenth century, when they could sell wines and spirits, and then, from the latter part of the nineteenth century, these establishments rebranded themselves as hotels. In Thornbury, the inns that became hotels were the Exchange, Royal George, Swan and White Lion and, as such, they usually provided food only to residents. It was not until the 1930s that food, or initially snacks, began to appear in the former beerhouses of the town. Smiths potato crisps were among the first items on sale.

These came in one flavour, plain, with the salt supplied in the packet in a twist of blue paper. After the Second World War, biscuits began to appear (these were of two types, shortbread or ginger snaps, in packets of four costing 3*d*) along with cheese straws and packets of peanuts. Picked eggs and onions also became available, and then, in the 1960s, sandwiches and the ubiquitous ploughman's lunch were added to the fare. Hot food started with just pies and pasties and has now developed so that most of the town's pubs have a wide and varied menu available. Food has become a major item to attract customers and, to entice abstainers, a choice of various coffees are now available for diners to have with their meal.

Temperance

From the Restoration in the sixteenth century up to the earliest part of the twentieth century, the Temperance movement was active in their efforts to suppress, or at least curtail, the consumption of alcoholic liquor. Their early efforts were not organised as it was left to individuals and chapels to strive to ban drinking, the weakness of this approach being the religious overtones and the rather po-faced attitude of its exponents. The general public were lectured about the evils of drink on a Sunday and then left with little or no support throughout the week for those contemplating abstention. The efforts of the Temperance movement were not helped by the fact that many employers gave a certain amount of beer to their workforce as part of their wages. It was only when like-minded individuals found themselves together, either by chance or design, as members of parliament, that they were able to influence their fellow politicians and, over the years, from the mid-eighteenth century, push through the legislation previously mentioned.

One person who pushed his Temperance beliefs, both as an M.P and as an individual, was Sir Stafford Howard of Thornbury Castle. In 1880, he and his wife, Lady Rachel Howard, convened a meeting of the Church of England Temperance Society at the castle, and that year, they opened a coffee house in the recently vacated Attwells school-building in St Mary Street. This proved to be a successful venture, and they soon needed larger premises, so when the second Beaufort inn closed, in 1889, it moved there and opened as the Castle Coffee House and Temperance Hotel. Sir Stafford Howard took a keen interest in his Temperance work, even employing reformed drunkards so that he could keep an eye on them. This was in contrast to his father, Henry Howard (died 1875), who was one of the employers who supplemented his staff's wages with beer. The Temperance Hotel remained in existence until 1919, by which time the Temperance movement, having met its more moderate aspirations, gradually petered out.

Widespread drunkenness does not appear to have been a problem in Thornbury when compared with other places, exceptions were the rioters who wrecked the town's ducking stool in 1605 fuelled by drink, likewise the mob that attacked a Salvation Army procession through the town in the 1880s. Drunkenness, when it did occur, was not

confined to the menfolk. In 1869, Catherine Alexander, the wife of a chimney sweep, was fined 5s, with 6s and 6d costs, for being drunk and riotous in the Wheatsheaf. She was also required to pay 4s for breaking windows at the police station. The relative sobriety of the townsfolk was even used as a reason by 269 local gentry and landowners who, in 1842, petitioned against an increase in the County rates, which was needed to fund the extension of the police force to cover rural areas. The petitioners stated that any disturbances could be met by the resources they already held.

THORNBURY, GLO'SHIRE.

To WINE & SPIRIT MERCHANTS,

Brewers, Licensed Victuallers and others.

Plan Particulars and Conditions of Sale, of a

FREEHOLD, FULLY LICENSED,

and MUCH FREQUENTED

PUBLIC-HOUSE,

Situate near the Railway Station, on the East Side of the High Street, Thornbury, and known as " **MICHAELS**,"

TO BE SOLD BY AUCTION, ON THE PREMISES,

BY

MESSRS.

EDWARD LUCE & PERTWEE

On Wednesday, April 27th, 1892,

AT THREE O'CLOCK IN THE AFTERNOON, PRECISELY, IN ONE LOT.

Advertisement for the sale by auction of Michael's pub (Gloucester Records Office).

TWO

PRESENT DAY PUBS

Anchor

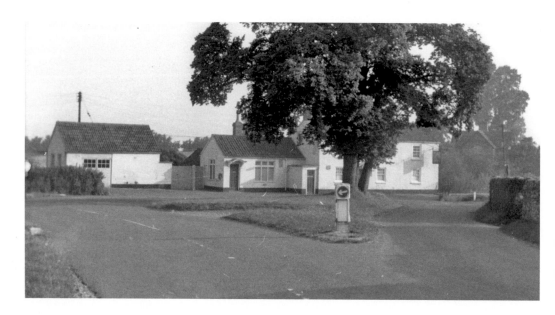

In early times, the Anchor was a prominent part of a small group of dwellings clustered around the nearby mill in an area that was then called Woolford. The earliest record of this inn appears in the tithe survey of 1696 when it was known as the Blue Anchor. A link to this early name was maintained until recently, with a blue anchor painted on the north wall of the inn. As there appears to be no break in trading from 1696, the Anchor has the second longest historical lineage of the Thornbury pubs, and probably the longest in one building, as the step in the chimney flashing indicates that the roof was thatched in earlier times.

Being the only commercial building in the immediate area, the Anchor was, for many years, also the local grocer and pork butcher. When the property was sold at auction for £685 to the tenant, Henry Honeybourne, in 1879 it included stables, piggeries, slaughterhouses and the inevitable brewhouse. Some of these outhouses survived until the 1960s, as seen in the photograph above. Brewing on site probably finished about the time of the sale, as up to 1887 beer was supplied by Perretts Bournestream Brewery at Wotton under Edge. That year, Perretts combined with another brewer, Arnolds of Wickwar, to form Arnold Perrett & Co., with all brewing being concentrated at Wickwar. Arnold Perrett & Co. were later taken over by Cheltenham Original Brewery in 1924, by which time the Anchor had lost its free house status and became a tied house. Four further changes of ownership occurred, all due to brewery mergers and takeovers. Firstly, in 1946, Cheltenham combined with Hereford Breweries to form Cheltenham and Hereford Breweries, which then combined with Stroud Brewery in 1958 to form West Country Breweries. This combine was then taken over by Whitbread's in 1962, who, in 2002, sold their pubs to the present owners, Enterprise Inns.

Like several other pubs in Thornbury, the Anchor was used until the early part of the twentieth century as a venue for inquests into sudden deaths in its neighbourhood. On one occasion in 1879, it was also used as a temporary mortuary to hold the body of a female tramp who had been murdered at a nearby Pit Pool.

At the beginning of the Second World War, a concrete pillbox was sited in the fork of the road outside the Anchor. Manning this was a sought-after assignment by the local Home Guard, as they could stock up with a few bottles of 'refreshment' to see them through the night.

After the war, the social side of the pub's life centred on the darts team. It started in the Thornbury league in the 1950s, but by the mid-1960s, it had transferred to the Berkeley league to which it supplied three teams. At that time, Frances Abrahams, wife of the licensee, started organising an annual flower show in the pub garden to raise money for the League of Friends of Thornbury Hospital. In more recent times, the customers have taken to playing boules, one of the few pubs in Thornbury to do so.

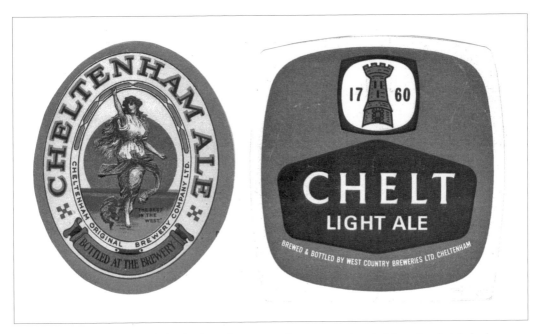

One bygone feature of the drinks industry was the many and varied beer bottle labels that were produced. Over time, these progressed from the stylish and decorative version printed by the Cheltenham Original Brewery (above left) to the more bland and cheaper to print version of the West Country Brewery.

Barrel Formerly Porter Stores

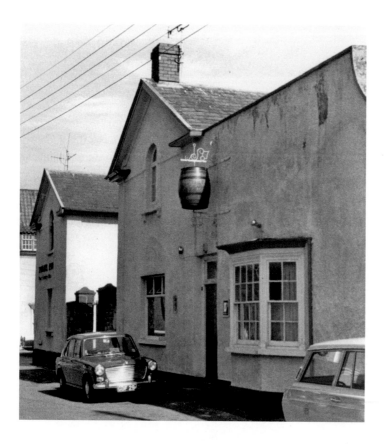

The twin two-storey buildings of today's Barrel were once the outbuildings attached to the gentleman's residence that is now Thornbury Town Hall. When the owner, William Ralph, died in 1859 this large property, stretching from the High Street to St Mary Street, was sold in two lots. The outbuildings — consisting of coach house, stables, yard, brewhouse and part of the garden — were purchased by Thomas Arnold, a brewer from Wickwar, for £290. This purchase gave him another outlet for his brewery, as a beerhouse situated on the north corner of the stable block adjoining St Mary Street had been trading since at least 1840. This outlet was now given the name The Ale and Porter Stores, which, being a rather long-winded name, became widely known as just the Porter Stores.

The brewers at Wickwar became dogged by financial problems and received two loans from a Thomas Halsey of Prestbury; the first, in 1864, was for £2,000, the second, in 1872, for £4,000. For the second loan, the deeds of the Porter Stores was one of several handed over for security. Eventually, in 1876, Thomas Halsey assumed control of the brewery, which now traded under the name of Arnold & Co. Later, in 1887, when Arnold & Co. combined with Perretts of Wotton under Edge, ownership of the Barrel followed the same sequence as the Anchor.

Some of Arnold's financial problems may have stemmed from the rent arrangement they had with their tenants, which was carried over into the new company. This arrangement stated that the rent agreed where a licensee took over one of their pubs would stay the same for the duration of his tenure. After Cheltenham Original Brewery took over Arnold and Perretts in 1924, they tried to overturn this arrangement, but a clause was found in the contract stating that it was binding on the brewer and their successors. A lengthy legal battle followed, which was fought by all Arnold & Perrett tenants through the Licensed Victuallers Association. A compromise was finally reached in 1936, when it was agreed that the rent would be raised but was then to remain the same for the remainder of each tenancy. When Frederick George Ford took over the Porter Stores from his father in 1921, he had the one rent rise during his time until he retired in 1956. Another local licensee who benefited from this arrangement was Henry Honeybourne, who was licensee of the Anchor for over thirty years.

For some time in the 1870s, Arnold & Co. had been trying to buy the freehold of the White Lion in the High Street but to no avail, so between 1879 and 1882 they rebuilt the Porter Stores. This entailed moving the bar into what was the coachhouse and enlarging the stable block to take four horses. The latter enabled them to entice one of the town's carriers away from the White Lion and make the Porter Stores its depot. Various carriers continued to be based at the Porter Stores until 1918 and the advent of motor transport. When the Cheltenham brewery became the owners in 1924, one consequence was the need to change the name. The existing Cheltenham-owned off licences were called Porter Stores, but as the Thornbury Porter Stores was an on licence it did not fit this naming system. Why the name Barrel was chosen is not known for certain, but an inventory of fixtures and fittings on change of tenant in 1911 mentions a 60-gallon cask. So, if that large barrel was still in existence in 1924 then that may be the reason.

During the first half of the twentieth century, the Barrel built up a cider trade until, by the early 1950s it accounted for over half of the takings, the cider being supplied from the converted brewery at Wickwar. There then followed an eventful period in the second half of the century. Firstly, throughout the 1960s, the Barrel was under threat of being demolished as part of the plan to redevelop the town centre. When this plan was finally rejected, minor improvements took place until 1982, when Whitbread's, who by then were the owners, embarked on a major enlargement project. The yard was levelled and covered over enabling the two blocks to be joined to give today's layout. Later, in 1997, after some more minor improvements, Whitbread's let it be known that it intended to change the name again, this time to Ebenezer Rileys Old Coach House. This did not meet the approval of the customers or the town council, so the Barrel lives on.

The Barrel is unique among Thornbury pubs in that it can lay claim to a ghost called 'Ben'. There was once a painting of Ben hung in the pub, depicting him working as a farrier, and this painting would never hang square but always tilted one way. When Andy Bawn was licensee (1986-1989) Ben became more active and was deemed responsible for throwing glasses around after hours. When Andy left, the incoming tenant took no chances and had the pub exorcised.

Copy

Dated 2ⁿᵈ *August* 1921.

ARNOLD, PERRETT & Co., LIMITED.

TO

Mr. *Frederick George Ford.*

LEASE of the

"Porter Stores"

RENT £ 15 : 12 : 0
Increased to £20 P.A.
 See Endorsement

TERM :
 one year.

Herrick Wotton.

It is hereby agreed that as from the 25th day of March 1936 the rent of the Barrel Inn Thornbury referred to herein as The Porter Stores Thornbury shall be increased by FOUR POUNDS EIGHT SHILLINGS (£4--8--0) that is TWENTY POUNDS (£20) per annum instead of FIFTEEN POUNDS TWELVE SHILLINGS (£15--12--0) per annum as herein stated.

As witness the hands of the parties this 9ᵗʰ day of *April* 1936;

Signed by William Albert Lambert for and on behalf of The Cheltenham Original Brewery Company Limited in the presence of

W. A. Lambert

E. H. Yeend
Ivory Avenue
Cheltenham

Signed by the Tenant in the presence of

Frederick George Ford

Endorsement of the one rent increase of the Barrel between 1921 and 1956.

Black Horse

Today's Black Horse Inn at Gillingstool is Thornbury's newest pub, having been built in 1972 to replace the one pictured above. This original pub was a typical roadside beerhouse, the earliest reference to it being in the 1851 census and the earliest date to it being called the Black Horse being in 1881. This pub was situated in the position of the present pub's car park and was a free house in its early days, a status it had lost by 1891, when it was owned by George Playne of the Forwood Brewery, Minchinhampton. In an era when brewers were consolidating and merging for economical reasons, Playnes were taken over by Stroud Brewery in 1897. Stroud Brewery remained the owners until 1958, when West Country Breweries were formed after the Stroud and Cheltenham and Hereford breweries combined.

Due to the housing development in the vicinity and its rather cramped interior, the original pub was demolished after the present one had been built by Whitbread's, who had been the owners since 1962. When the new pub opened, several skittle teams from other pubs in Thornbury relocated to the Black Horse to use the new alley — among them Swan Ladies, who became Black Horse Ladies, and White Lion Ladies, who became Black Horse Sidesaddlers.

A feature of the old pub, which is not visible in the above photograph, were the white curtains to the lower half of the ground-floor windows. Curtains were a characteristic part of many pubs from Victorian times onwards, foisted onto pubs by the Temperance campaigners, who wanted drinkers screened from the sight of respectable people. Some pubs used frosted or stained glass in the windows in lieu of curtains. The drinkers did not object, as their bosses were also unable to look in and see them.

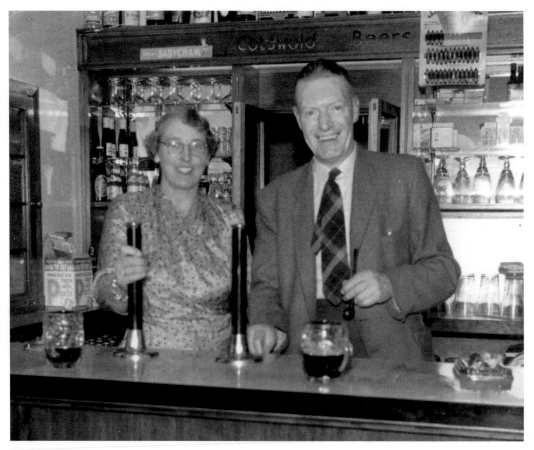

Mine hosts Cecil Palmer and his wife behind the bar of the original Black Horse in 1961.

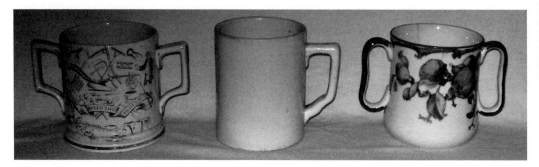

Cider has traditionally been drunk from china mugs. Above is the standard pint pot used in pubs, flanked by more decorative versions for use at home.

Knot of Rope Formerly Michaels, Royal Exchange, Exchange

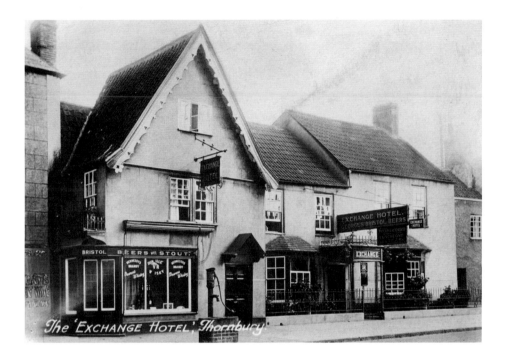

The 'EXCHANGE HOTEL' Thornbury

As can be seen from the roofline, the Knot of Rope was once three separate buildings. Up to 1889, James Merritt Michael traded as a wine and spirit merchant with an off licence in the two right-hand buildings (see chapter four). That year, he obtained the licence from the nearby second Beaufort Inn when it closed and opened his own fully licensed pub. As his off licence had been known as Michael's, he continued to use that name for the new pub. In 1892, the pub was sold at auction to Richard Hobbs Smith, a retired farmer from Olveston, for £1,900. Over the following years, he then bought adjoining properties until it covered an area, as shown in the diagram overleaf. Firstly, in 1894, he bought a shop, dwelling house and yard facing St Mary Street and three cottages in Chapel Street for a total outlay of £260, then, in 1896, he purchased the gable-ended property in the above photograph for £630. This stretched back to St Mary Street and included a yard, garden and coach house, which had been converted into a coal depot. During this period, the inn was renamed the Royal Exchange and developed into a hotel. The new name, an early term for the stock exchange, may indicate the source of R. H. Smith's or his family's wealth. Over time, this new name became shortened in everyday parlance to just the Exchange and eventually became its official title.

When R. H. Smith sold this property to Ashton Gate Brewery of Bristol, in 1920, it lost its free house status but remained operating as a hotel. Ownership changed again when, as a consequence of the economic depression in 1930s, Ashton Gate Brewery went into liquidation in 1933 and Georges, another Bristol brewery, took over all their

pubs. Some of the outbuildings of the Exchange were rented to various traders and the stables used to accommodate the horse which pulled the LMS railway parcels delivery cart. This arrangement was to last until the 1940s.

Soon after the Second World War broke out in 1939, all the rear part of the Exchange was commandeered for military use. The first unit to occupy the buildings was the 68th Searchlight Regiment RA, who used the assembly room as their regimental headquarters. When they moved out it became the quartermasters' stores for the 6th Maritime Regiment RA. After the war, the outbuildings were again put to various uses, including part being used as changing rooms for Thornbury Town football club, until in 1957, when a large section was sold to Tucker Bros, a local building firm.

Another change of ownership occurred in 1961 when George's brewery was taken over by Courage. Then, in 1973, the Exchange regained its free house status when Kenneth Richards bought the property. Around this time, a very misleading inn sign appeared on the front of the building. This showed an ostler leading a pair of horses and gave the wrong impression that the Exchange was once a coaching inn.

The Exchange reverted to being a tied house when Kenneth Richards sold it to the Wolverhampton and Dudley Brewery in 1982. When it re-opened after a refurbishment, the name was changed to Knot of Rope, which is both the emblem of the brewer's home county and that of the Stafford family, who owned Thornbury Castle for over 300 years.

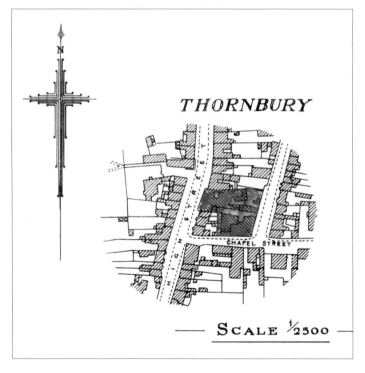

A diagram taken from a title deed showing the extent of the Exchange property after the purchases of R. H. Smith in the 1890s. It was to remain as such until the 1950s, when parts began to be sold off.

Plough

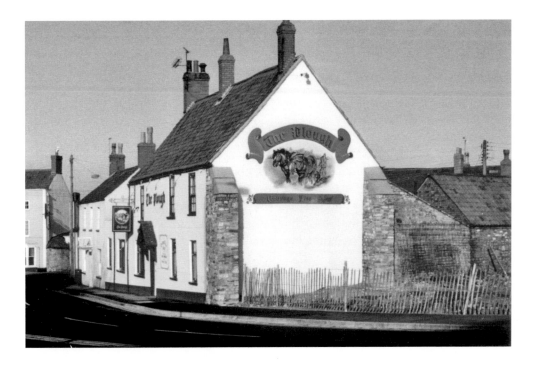

The early history of this inn, built in the mid to late eighteenth century, is somewhat complex. There are two old documents, one dated 1833 and the other dated 1839, which refer to a property called the Seven Stars, obviously a beerhouse, located in Nelme Street (the old name for St Mary Street) and Trumpleton Street (the old name for St John Street), which places it where the Plough now stands. As the earliest record of the Plough being open as a beerhouse is 1858 and with no mention of a beerhouse on this site in the 1841 census, it can be assumed that the Seven Stars closed before 1841, with the name transferred to a beerhouse in Rock Street. In the years between this closure and the opening of the Plough, the property was occupied by Sam Lovegrove, a wine and spirit merchant.

The magistrates in Thornbury, like many places elsewhere, were under pressure from the Temperance movement to restrict the number of outlets for the sale of beer. This was achieved by not issuing new licences, so anyone wishing to open a beerhouse had to obtain the licence from one closing down. The transfer of the Seven Stars licence between locations illustrates this policy and was repeated with the opening of the Plough when its licence was obtained from the Star beerhouse in St John Street when that closed. It is possible that the new name was chosen as a link to the old, the celestial configuration of the seven stars being the shape of a plough.

Who supplied beer to the Plough in its early years is not known, but by 1889, it was owned and supplied by Daniel Sykes & Co, Redcliff Brewery of Bristol. This brewery

was taken over in 1897 by Bristol United Breweries, who remained the owners until 1957, when they, in turn, were taken over by another Bristol brewer — Georges.

Like several other pubs in Thornbury, the Plough was used in the early part of the twentieth century to hold inquests into sudden deaths in its immediate vicinity. On 10 January 1900, an inquest was held at the Plough into the demise of Eliza Fowler, aged seventy-seven, an inmate of the nearby almshouses who had burnt to death the previous Saturday. A high proportion of these pub inquests into sudden deaths of old people found the cause of death to be burning. It is not difficult to imagine an old person huddled over a fire for warmth and either falling asleep or being overcome by fumes, with fatal results.

The Plough has been, for many years, a prominent skittles pub, with the alley in use most nights of the week. Besides the pub teams others, which have used the alley, had such diverse names as the Munsters, Oldbury Consultants, Polly Packers and Shandys Gang.

One bygone feature of this pub was that when the adjoining property was demolished the south facing wall was used to display a colourful mural, but this was lost when Quaker Court old people's accommodation was built.

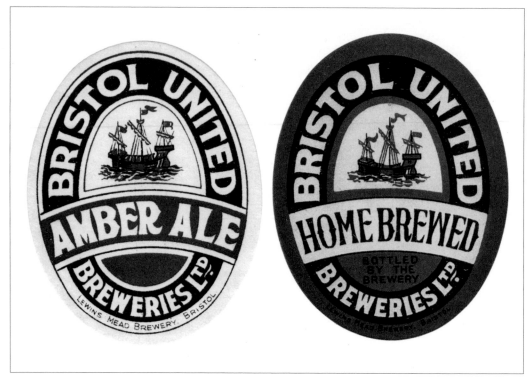

The Bristol United Breweries used Cabots ship as their trademark on their bottle labels and, like other brewers, sold their speciality ale under the name 'Home Brewed'.

Royal George Formerly Boars Head

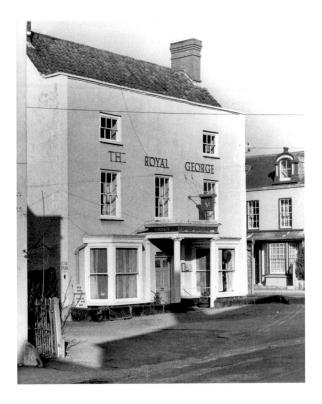

This inn occupies a Grade II listed building, which was constructed in the early to mid-nineteenth century. The date when it first started trading is not known, but by 1858, it had taken the name of Boars Head and remained as such until 1875, when the new owner, James Knapp, renamed it the Royal George.

Early licence holders followed the normal custom of the time in having a second occupation. George Phipps, who had previously been at the Cross Hands in Kington, was listed in the 1881 census as also being a blacksmith, probably at the adjacent premises, now Thornbury MX, while Samuel Phipps (1910-1923) operated a carrier business from the inn.

Thornbury Mop Fair, whose main purpose was the hiring of agricultural labourers and domestic staff, was, for many years, held in the spring on the Plain. When this fair shrank it was held in the yard at the rear of the Royal George until it died out in the late 1880s.

Many organisations used the Royal George for meetings, among them the Ancient Order of Foresters Lodge, No. 4365. These would gather on a certain day in June, with men dressed as Robin Hood and on horseback, and parade around the town preceded by a band. They would stop at every pub before going to the church for a service and then continuing around the town.

The road outside the Royal George was the scene of what could possibly be Thornbury's first fatality from a road traffic accident. In April 1901, a pedestrian staggered into the path of a horse-drawn cart coming around the corner, was knocked backwards and fractured his skull on the road. The subsequent inquest was held at the Royal George and a verdict of accidental death recorded.

In 2004, there was a divergence of opinion between some local townsfolk and the then pub owners, the Unique Pub Company, as to what the Royal George was named after — was it a monarch or a ship? When the owners put up a sign on the corner of the building depicting a monarch's head this was said to be incorrect. It was stated, at the time, that the pub sign had been that of a warship 'for as long as anyone can remember', so the monarch's head sign was replaced with one depicting an old sailing warship. The above photograph, taken in the late 1960s or early '70s, shows the building without a sign, as do other photographs taken as far back as 1910. The subject of the sign's derivation is examined further in Appendix 4.

About the same time, another feature of the pub's frontage was discussed, namely the coloured leaded glazing in the lower windows. The Unique Pub Company wanted to remove them but were told they had historical significance, so they remained in place. Again, this coloured glass is not shown in the above photo, neither is it shown in the earlier ones.

More recently, the pub has undergone a complete refurbishment, with the new owner turning it into a Mediterranean style lounge bar and restaurant. The controversial pub sign has been removed and replaced by a rather bland and abstract depiction of a three-masted sailing vessel, while the coloured glass panels have been removed from the windows and incorporated in the internal décor.

See also the BELL in Unlocated Pubs, chapter three.

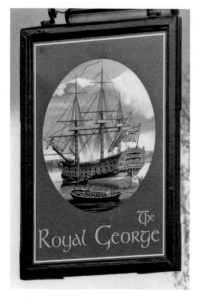

The 2004 controversial pub sign.

Swan

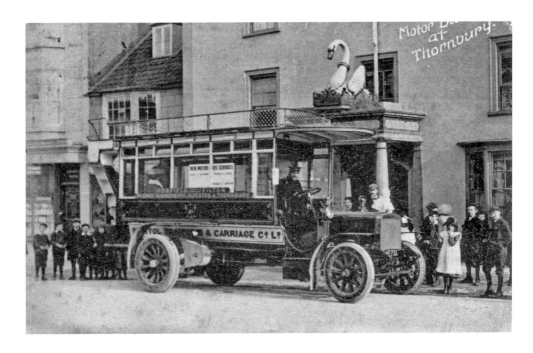

For many centuries, the Swan has been the pre-eminent pub in Thornbury. The earliest record of its existence is in 1642, but it undoubtedly pre-dates that year, as a swan is one of the heraldic symbols of the Duke of Buckingham, so in all probability it was established during his time in Thornbury (1498-1521). Parts of today's building date from the seventeenth century, but the major part is the result of a rebuild in the eighteenth century, when the height was extended to three floors and the two pineapple-shaped finials placed on the roof as a sign of hospitality.

The Swan was the only coaching inn in Thornbury and was one of the stops on the route between Bristol and Birmingham. The mail coach from Bristol would arrive in the evening at 8.30 p.m. and the one from Birmingham at 5.30 a.m. in the morning. The clatter and bustle associated with this early morning arrival must have been a regular alarm call for adjacent trade's people who, at that time, all lived over their shops. The through mail coaches stopped running in 1845, when the railway line between Bristol and Gloucester was opened.

The licensee of the Swan, as well as overseeing the dispatch and receiving of mail, was responsible for collecting the excise duties from other traders in the town and surrounding area. Hence the suffix 'Postage and Excise' to the Swan's name whenever it was mentioned in trade directories (see also Appendix 1).

A cash book exists itemising the day-to-day running costs of the Swan in the late eighteenth century, when it was owned by the lord of the manor at Thornbury castle, and contains some interesting items. They include:

	£	s	d
22/5/1789 Paid of Bevan for Court Leat diners wine (*F Bevan was the licensee*)	3	18	0
6/1/1791 Excise duty for Swan	4	17	5
14/7/1791 Land tax		10	0
5/10/1791 James Shears for sweeping chimneys		4	0
12/1/1792 The workmen when building Days House and repairing the Swan drank three hogsheads of cider and beer (*drink was supplied to workmen as part of their wages*)	9	9	0
20/3/1794 Horse flesh for painter (*what this was used for is not known*)		4	6

The building itself was also put to other uses and was the venue for the quarterly Petty Sessions, which were held in what is now the function room. This ceased when the police station opened in 1860. Auctions, inquests and public meetings were also held at the Swan; one notable meeting, which attracted a large attendance, was held in 1861 and chaired by the mayor, Mr H. H. Lloyd, to discuss the possibility of connecting Thornbury to the railway from Bristol. Also, many years later, before radios were in general use the results of parliamentary elections were announced from the portico over the front door.

The original swan, shown in the photograph, was placed on the portico in 1844 and had a crown around its neck to show it was a royal bird. This swan survived for almost a century, being replaced sometime in the 1930s by one without a crown, and has remained there ever since, except for one morning in living memory when it was missing. It was later found in the stream in the Mundy playing fields, having been removed by revellers the previous evening.

When motor buses commenced running to Thornbury they initially carried on the mail coach custom and used the Swan as their stopping point before moving to the Plain and later to the present-day stop at the bottom of the High Street.

The Swan was the only pub in town to be affected by the First World War. From 1898, its beer was supplied by the Anglo Bavarian Brewery, Shepton Mallet. This brewery, as its name implies, used the skills and techniques of brewers brought over from Bavaria and was the first brewery in England to produce a lager-type beer as well as more conventional brews. It won many brewery prizes worldwide, but when war broke out in 1914, anything to do with Bavaria or Germany was ostracised, forcing the brewery to close and the Swan to find a new supplier.

In more recent times, Joe Whitehead, who was licensee from 1955-71, was one of the founders of the Thornbury and District Skittles League and served on the committee for many years. The alley at the Swan was used by many teams and was created from part of the old stables, two stalls of which survive to the present day. These stables were used in the past to accommodate a number of horses as changes for the mail coaches and later to pull the many carriages available for hire to the public. A horse stabled here was also used to pull the town's fire appliance when it was needed. The appliance being housed in the nearby former malthouse opposite the Plough.

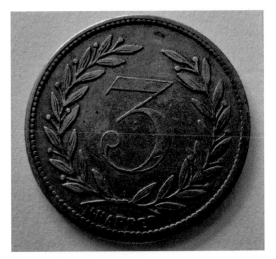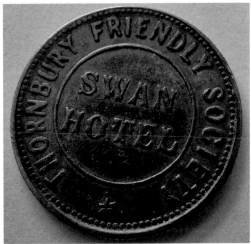

The Thornbury Friendly Society was one of the organisations which made use of the facilities at the Swan in Victorian times, and the above token, worth three old pennies, was part of what was called the 'wet rent' arrangement the society had with the owner/licensee of the Swan. When members of the Society arrived for their meetings, they would pay their dues and then be given a token, which had to be spent on drink that night after the meeting. This was in addition to the normal rent the society would pay to cover such things as lighting and heating.

This wet rent arrangement was widespread within friendly societies and similar organisations, and was a very contentious issue. If one party felt aggrieved then the society usually moved to a different venue, as happened in Thornbury after the Friendly Society had been absorbed into the larger Foresters Friendly Society and they moved to the Royal George. Wet rents were still common practice until the early part of the twentieth century.

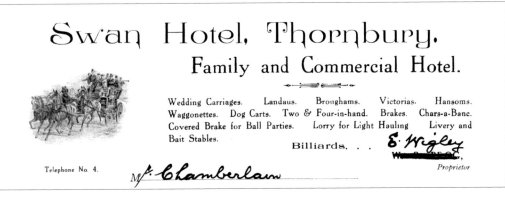

A billhead from 1918 showing the means of transport available from the Swan.

The Georgian bow-shaped window in what was the courtyard, with a high level window within a window, which allowed drinks to be passed to horse riders without them dismounting.

Wheatsheaf

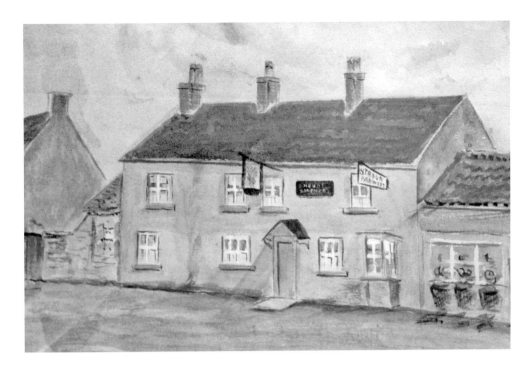

The above is a copy of a painting done in 1898 of the original Wheatsheaf. The earliest mention of this beerhouse is in 1841, when a John Williams was the owner/occupier. His occupations at that time were brewer and beer-house keeper, indicating that he brewed his own beer on the premises. When brewing ceased is not known, but from about 1891 to 1897, George Playne, of the Forwood Brewery at Minchinhampton, was the supplier.

Just before Thornbury cattle market moved from the High Street to the site at Streamleaze in 1911, Stroud Brewery (who had taken over George Playne in 1897) applied to knock down and rebuild the Wheatsheaf. This was approved with the proviso that the frontage be 15 feet back from the then street line. On 1 December 1911, the brewers accepted the lowest tender of £1,782 for the work, which commenced immediately after Christmas.

The inn was completed in an architectural style known as 'Brewers Tudor' (because of its pseudo wooden frames on part of the upper storey) just in time to feel the effects of the First World War. During 1914 and 1915, many men had volunteered for service in the army, and by 1916, those left behind were being conscripted. This led to a considerable drop in the number of customers in all of the pubs in the town, with the resultant drop in income for the licensees. This resulted in a price war between brewers who, in an effort to attract trade to their houses, kept prices as low as possible. At this time, Stroud Brewery were selling their popular Harvest ale at a wholesale price of 9*d*

per gallon. Even this low price was not enough to stop Daniel Howes, the licensee of the Wheatsheaf, appealing to the brewery directors in July 1916, stating that he was being undersold by the nearby Queens Head, owned by Georges of Bristol. The price difference between the two brewers could not be resolved so Daniel Howes was given a £5 reduction in his annual rent.

With its proximity to the cattle market, the Wheatsheaf quickly became the farmer's pub on market days. When the opening hours of the town's pubs were restricted by the 1921 Licensing Act, the drinking time available for market goers was limited even more due to the auctioneering taking place around midday. To compensate for this inconvenience, the Wheatsheaf was allowed to extend its afternoon opening times, but then had to reduce its evening opening time by the same amount to stay within the stipulated eight hours per day maximum.

When Thornbury had a station, the Wheatsheaf was also the railwayman's pub. The engine driver and fireman would leave their engine simmering on the platform and nip down what was then the station approach road, over the garden wall and into the pub via the back door.

The internal bar arrangement of the Wheatsheaf has altered very little since the pub opened except that the space occupied by the original Bottle and Jug has been incorporated into the lounge bar.

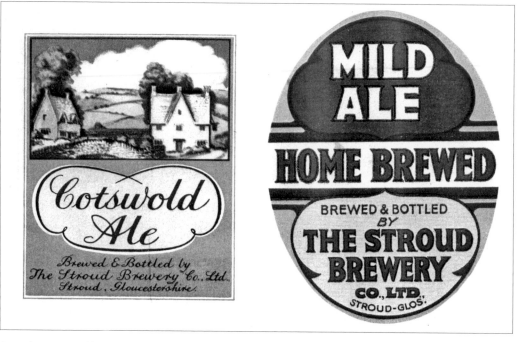

Stroud Brewery like to regard themselves as a rural brewer and named some of their beers accordingly, with titles such as Harvest ale and Cotswold ale. Like other brewers, they also had a special home-brewed beer.

White Lion Formerly Rover

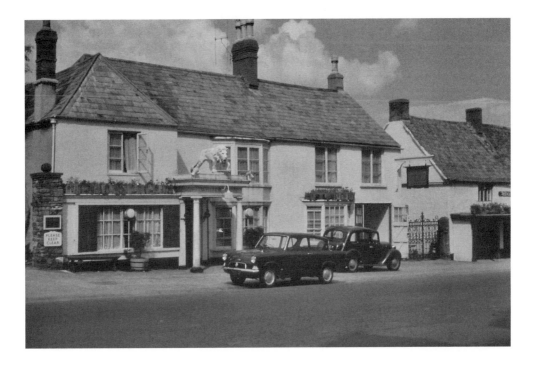

The early history of this pub is uncertain, but in 1840, the building was owned by Thomas Wetmore with James Prewett as tenant and listed as beer-house keeper and coach proprietor. The building is of seventeenth-century origins but was enlarged in the 1850s when it took the name of White Lion. For sometime prior to this it was known as the Rover Hotel. The name change is believed to be in recognition of the Howard family, who around that time had taken up residence in Thornbury Castle, white lions being a prominent feature of their coat of arms. A wooden lion was also placed over the portico of the pub. The following is part of a lengthy letter written in rhyming local vernacular by Clodpoll in 1857 to a friend in Bristol describing these changes:

> Th' premmusiz where Prewett lived (Th' Rover)
> Have bin inlarged and nicely painted over
> Th' pleece lucks better than a did afore
> And there's a monstrous lion o'er the door
> Wen a wur vust put up th' landlord vow'd
> He's caaze th' hanimal to roar zo loud
> That wother beasts and birds shood veel dismay
> Espeshully the Zwan across th' way
> Howe'er the long neck'd burd was nat alarm'd
> And still rests on her bed of flags unharm'd

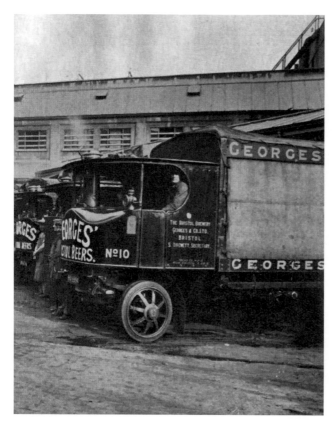

During the Second World War, Georges Brewery used steam lorries to deliver beer to the White Lion and their other pub in Thornbury, the Queens Head. Under the zoning restrictions brought about by petrol rationing, Georges Brewery also supplied the two Cheltenham Brewery pubs in town, the Anchor and Barrel, from 1940 to 1946.

During the 1860s, a horse bus ran from Oldbury to Patchway railway station and used the White Lion as its stopping point in Thornbury. Also, because of its central position in the High Street, the White Lion was used by carriers, but, due to its lack of sufficient stabling for the horses, it was only used as a pick up point and not as a depot. Arnold & Co., the brewers from Wickwar, who at that time supplied the beer to the White Lion, tried to purchase it from the owners in the 1870s, with the intention of enlarging it to provide sufficient stabling. When their offer was rejected, they turned to their other property in Thornbury, the Porter Stores, rebuilt that, and made it into a fully-functional carrier depot and, in so doing, enticed the carrier away from the White Lion.

An 1876 document gives a detailed description of the property. It states:

Situated in the centre of Thornbury is an old establishment and well accustomed double licence house known as the White Lion where a good business is being done. The premises are well situated in the centre of the market having bar and bar parlour, smoking room, tap room, sitting room, bedrooms, kitchens, cellar, coach house and stabling; there is a brew house, a large bowling saloon and large clubroom used by Foresters and Oddfellows clubs with nearly 300 members, a good walled garden and yard.

The mention of a brew house suggests that in its early days this pub was another that brewed its own beer.

Between 1861 and 1915, the White Lion was owned and operated by the Hall family and is a prime example of a pub-owning family business being handed down through the generations. The family members involved were:

James Hall

Josiah Hall – son of James

Mary Ann Hall – wife of Josiah

Frederick Hall – son of Josiah and Mary Ann

Prior to coming to the White Lion, James Hall had been a cider dealer at Kington and licensee of a pub in Chepstow. His youngest son, Walter, was also in the trade, being licensee of the Royal George in Thornbury between 1871 and 1879.

The moving of the market from the High Street in 1911 had little effect on the viability of the pub as it still functioned as a hotel and meeting place for various clubs and organisations. During the Second World War, Dolly Parsons, the wife of the licensee, was much admired by the servicemen stationed in the town for the social work she did for them. When she was widowed she moved and took the licence at the Black Horse at Gillingstool.

The original wooden lion over the doorway survived until October 1971, when a late-night reveller climbed onto the portico and tried to ride the beast. It was in such a worm-eaten state that it immediately collapsed, all this happened without wakening the licensee. The replacement, made of moulded fibreglass, was fitted the following year.

In 1999, the White Lion won the best pub floral display in a nationwide Britain in Bloom competition. Recent internal renovations have seen all the bars and what was the coach house and stables incorporated into one large bar area. Because the pub is a listed building, the façade cannot be altered, so the large doorway to the coach house, which was later used as a garage, remains and is now used as an emergency exit from the bar. See also the Crookhorne and Horse and Jockey in Unlocated Pubs in chapter three.

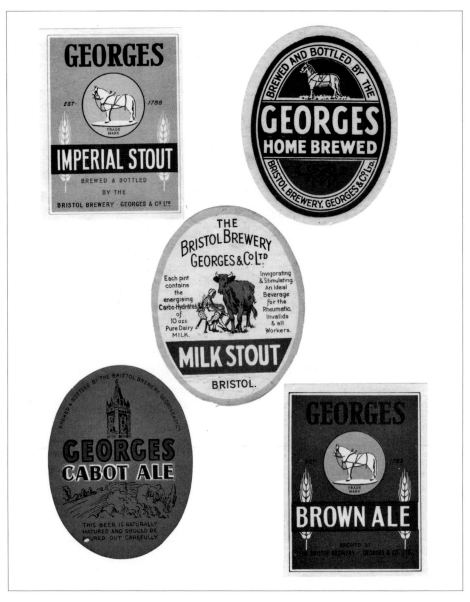

A selection of some of the products of Georges Brewery, three featuring their trade mark of a white dray horse. The Cabot Ale label states 'This beer is naturally matured and should be poured carefully', while the Milk Stout label exhorts its medicinal qualities stating 'Each pint contains the energising carbohydrates of 10 ozs pure dairy milk', and that it is 'invigorating and stimulating, an ideal beverage for the rheumatic invalids and all workers'.

Both the Anchor and Black Horse have retained one of these ceramic plaques on their outside walls, dating from the time when they were owned and supplied by a regional brewer. The castle motif was the trademark of the Cheltenham Brewery and featured on all three versions of this plaque. The first version had 'Cheltenham Ales' in the upper scroll, which was changed to 'Cheltenham and Hereford Ales' then to 'West Country Ales' as the brewery went through succeeding mergers. These plaques have been removed from the other two West Country Brewery supplied pubs in the town (the Barrel and the Wheatsheaf).

Street Layout of Thornbury Showing Bygone Pubs

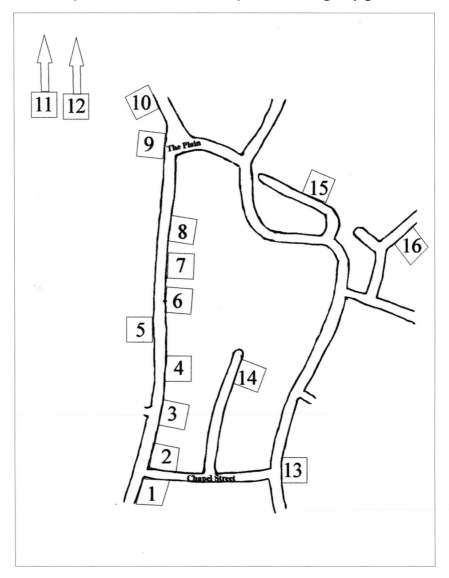

1. Beaufort (first location)	9. White Heart (first location)
2. Queens Head	10. Black Lion
3. Beaufort (second location)	11. Cockmead
4. Tigers Head	12. Lamb (first location)
5. George	13. Seven Stars
6. Tavern	14. Horseshoe
7. Lamb (second location)	15. Star
8. Crown	16. Crispin

THREE

BYGONE PUBS

1. Beaufort (First Location) Formerly Cock, New Inn

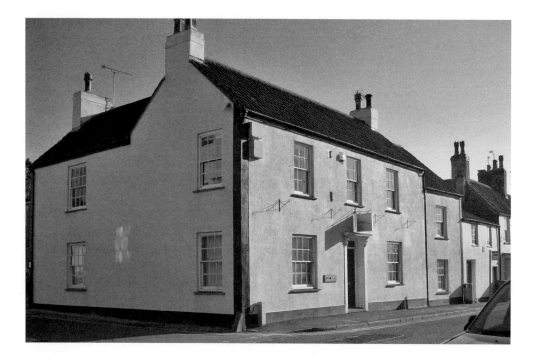

The present day No. 67 High Street, on the corner of Chapel Street and High Street, stands on the site of two previous properties, which each had a frontage width of half of today's building, the right hand or southerly part being where the Cock was situated.

The earliest reference to the Cock is in a document dated 1742, but it undoubtedly existed well before that date. Five years later, in 1747, the tenant died owing money for malt, which indicates that brewing took place on the premises. In 1773, the inn came into the possession of William Cowley, who that year bought the adjoining property on the corner. Some time thereafter, both properties were demolished and the present-day building erected and traded under the obvious name of the New Inn. This name is first recorded in 1779, when a James Roach was the tenant.

Ownership of the inn then passed through various members of the related Cowley and Grove families until 1834, when it was sold to Edward Doward, during whose time the inn name was changed yet again, in 1839, to the Beaufort Arms.

When brewing on the site ceased is not known, but by 1831, the brewhouse had been turned into a bakehouse. This facility attracted one of the town's bakers, James Screen, who bought the Beaufort Arms in 1847. Five years later, in 1852, the inn ceased trading, the licence and name being transferred to other premises further down the High Street at what is now No. 57. The property then became a house and bakery and traded as such for over 100 years before becoming offices as it is today.

2. Queens Head

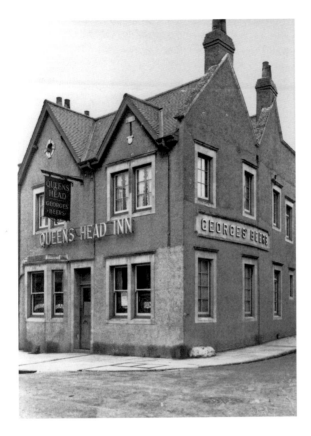

This pub on the corner of High Street and Chapel Street can trace its origins back to the mid-1800s when it was a grocers shop owned by Hugh Smart, who in 1858 obtained a licence to sell beer in addition to groceries. This licence was probably obtained from the neighbouring two guinea beerhouse at No. 63 High Street when that ceased trading.

At an auction held in the 'Swan' in November 1884, the property was sold to the brewers R. W. Miller & Co. of Bristol. It was then described as a 'freehold messuage comprising dwelling house and garden. The dwelling house containing shop, parlour, kitchen, pantry and underground cellar, three bedrooms and a small room'. After the sale, the grocery business was phased out and the name Queens Head adopted.

The 1904 Licensing Act gave magistrates the power to close licensed premises, which they deemed in excess of requirements for their area. At the 1905 Brewsters Sessions, when the police gave their annual report on the state of licensed premises, the Queens Head was one of two beerhouses in Thornbury recommended for closure. Their choice may have been due to the fact that there had been at least two cases of drunkenness on the premises in the preceding years. The brewer's lawyers, however, successfully fought their cause and the Queens Head retained its license.

In 1911, R. W. Miller were taken over by another Bristol brewer, Georges & Co, who then carried out structural alterations to give better accommodation and the external appearance as shown above. It remained a Georges' pub until it was closed in 1958 due to its small size and falling trade. It was the only six-day licence in Thornbury, which reflects is origins as a shop and the only pub to sell perry. Since closing, the building has been used as a doctor's surgery, offices and is now a café.

Two licensees are worthy of note, one William Underhill operated a carrier business from the pub between 1889 and 1902, and in the early years of the Second World War, Howard Lee was also the commanding officer of the Thornbury detachment of the Home Guard.

The top of the High Street showing the original façade of the Queens Head prior to the 1911 rebuild.

3. Beaufort Arms (Second Location)

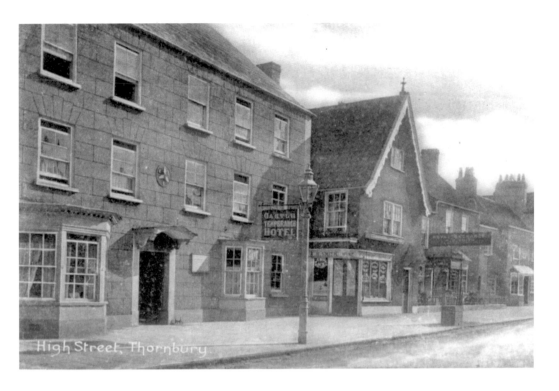

High Street, Thornbury

The present-day estate agents at No. 57 High Street occupy the site where the second Beaufort Arms once stood. This inn had a comparatively short life when compared with other inns in the town, but was a prime example of the practice of transferring licences between premises. The above building was erected some time after 1719, its early use is not known but the 1851 census lists it as being unoccupied. The following year, the owner of the Beaufort Arms at 67 High Street had decided to concentrate on baking, so the licensee, George Gunter, transferred to this building, bringing the name with him. It continued trading until 1889 when the licence was again transferred, this time to Michael's next door. The property then came under the control of Sir Stafford Howard, who reopened it as the Castle Temperance Hotel and Coffee Tavern, as shown above. It was then partially demolished in 1918 to make way for Thornbury's only cinema — the Picture House.

In the 1950s, there was an auctioneering business in Thornbury called Howes, Luce Williams and Paine. A predecessor of the Luce part of this firm, Edward Luce, was licensee at the Beaufort from 1871 to 1876, his occupation being listed as beerseller and auctioneer. After he relinquished the licence, among the other auctions he held he officiated at the sale of two Thornbury pubs, the Anchor, in 1879, and Michael's, in 1892.

4. Tigers Head

This inn, of which no structural evidence remains, had ceased trading by 1667. It had a rather bizarre name for an early English inn in a rural town and indicates a possible foreign influence. This could, perhaps, originate from the time when the local lord of the manor returned from a crusade to the Holy Land around 1370, where heraldic symbols were used for the first time.

A document, dated 17 October 1639, granted to Peter Hawksworth a messuage called 'le Wyne Taverne' for the term of his life, then to Robert Hawksworth and then to his heirs. A later document, dated 18 November 1699, shows a Peter Hawksworth the younger as owning a property formerly called Tygers Head, so with the Hawksworth connection it can be assumed that the Wyne Taverne and the Tygers Head were the same property. Another variation of the spelling being Tyger Stead.

Prior to 1699, the Tigers Head had been divided into two tenements, which were then rebuilt in the mid to late eighteenth century and, through ownership these tenements, can be traced to an 1810 document where each is described. The larger of the two tenements is described as then consisting of a 'shop, backside garden, orchard and appartenances covering half of a burgage adjoining the High Street thereon the westward part', while the smaller one consisted of 'a messuage or tenement, backside garden and orchard on the southward part thereof'. Tracing these two properties through ownership deeds, their location, and hence the original site of the Tigers Head, can be determined as being what is today's No. 51 High Street (Riddifords shop) and the adjoining No. 53. The early name of Wyne Taverne may suggest that this inn was the forerunner of the Tavern (see No. 6).

5. George Formerly Widows Mantle

Some publications written in the past on the history of Thornbury have erroneously placed the Widows Mantle at Porch House in Castle Street, but diligent work by a member of the research team at Thornbury Museum has found its true location in the part of the High Street once known as Pye Corner, on the site now occupied by St Peter's Hospice charity shop and the Frying Machine fish bar. The confusion arose because there are three buildings in the town, which, at various times, have been called Porch House.

The present building is mainly of seventeenth-century construction with later eighteenth-century additions, the decorative cast iron veranda being added in the mid-nineteenth century. Its original name of Widows Mantle implies that the inn was trading around 1520, which was during the Duke of Buckingham's time at Thornbury; the name is derived from one of the duke's heraldic emblems, the mantle of Brecknock. The name change is presumed to have taken place around 1760 to honour King George II, during whose reign Britain prospered at home and abroad.

Pye corner is believed to have taken its name from the Pie Poudre courts, which were set up to administer justice for any low-level misdemeanour associated with markets and trading. As Thornbury market was held in the High Street, and knowing that in

early times it was common practice to conduct business in inns, it is quite conceivable that Pie Poudre courts were held in the Widows Mantle.

In 1776, a flying coach known as the Diligence operated a service between the George and the Greyhound Inn in Broadmead, Bristol. This was a twice-weekly service on Mondays and Thursdays and only carried three passengers, each paying 3s for a return trip the same day or 2s for a single journey. Each passenger was allowed 7lb of luggage and small children, if carried on the passengers lap, went for half price. The entry in the Bristol journal advertising this service stated that the George had:

> Post-chaises and Saddle Horses to let at reasonable prices; Dinners provided and drest in the neatest and most reasonable manner on the shortest notice. The George Inn has been lately new fitted up and furnished proper for the Reception of Company.

After this inn ceased trading in the 1790s, it became a school for Quaker children, then a butchers shop, then returned to the drinks trade as the Victoria Wines off licence before its present usage.

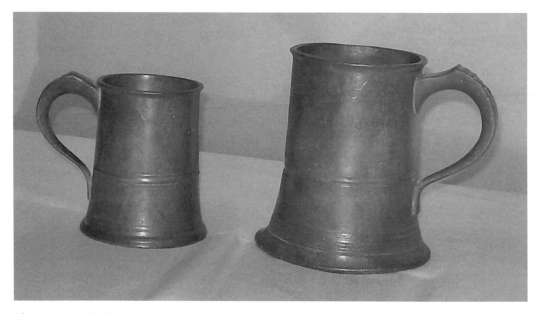

These pewter drinking pots were in widespread use in inns and taverns during the eighteenth century, having replaced the previous earthenware or wooden drinking vessels. From about 1770, these, in turn, were gradually superseded by glass pots as the public became suspicious of dark beers and changed to lighter clearer brews and wished to see what they were drinking. By the mid-1800s, the normal drinking measure had changed from the pewter quart to the glass pint.

6. Tavern

Today, there is no visible trace of the Tavern, which stood on the site now occupied by the town hall. However, unlike the present building, it is believed to have faced Silver Street. The name Tavern was initially used to denote an inn that catered for the professional classes (doctors, solicitors etc), where they could obtain food and wine, and was therefore considered to be more aloof than the common alehouses.

The earliest date when the Tavern was known to be trading is 1590, and the latest is 1774, when a Thomas Child was licensee. It was another establishment that brewed its own ale, as the deeds of the Barrel, which was once part of the same property, refers to a brewhouse amongst the list of structures.

The demise of the Tavern, like many others of its kind nationwide, started as a result of the 1753 Licensing Act, when taverns lost their monopoly on the sale of wine, and with the wide availability of cheap glass bottles, which enabled the customers to take their drink home. After the Tavern closed, it was rebuilt by George Rolph as a residence and leased to William Salmon in 1785. When his successor, William Rolph, died in 1859, the property was divided in two, half the garden along with the coach house, stables and brewhouse was bought by Thomas Arnold (see Porter Stores Chap 2), while the residence became the police station in 1860 after a new façade was added.

The early owner of the Tavern, John White, bequeathed it in his will, dated 1590, to Henry Harris, with the proviso that on the death of Henry Harris his heirs to the property were to pay 17s and 4d annually to the poor of Thornbury, which was to be distributed in the form of corn or money. The original sum was paid by successive owners throughout the years, the last recorded payment being in 1861 by the county police authority.

7. Lamb (Second Location)

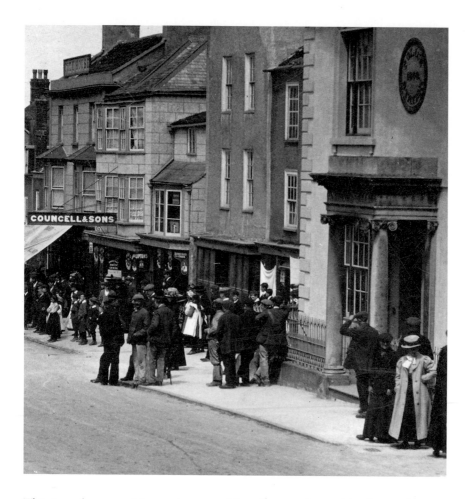

This inn, the second inn to be named Lamb, was situated in the High Street where the present day northerly or single-storey part of the Britannia Building Society now stands. The name and licence were transferred from the previous Lamb in Castle Street some time between 1759 and 1770 when that inn was demolished (see No. 12). Little is known of this inn except that during its latter years two members of the Bevan family held the licence. James Bevan is recorded as being the licensee in 1841, when it was owned by Harriett Mawley, followed by Thomas Bevan (presumably James' son), who was licensee between 1849 and 1861. The last reference to this second Lamb is found in the 1861 census, it having ceased trading before the 1871 census. This closure may have been as a result of the 1869 Wine and Beerhouse Act, which gave magistrates the power to close inns for misconduct and not complying with the licensing laws. After closure, the building remained standing until the early years of the twentieth century (as seen above), when it was an outfitters shop owned by a Mr John Hedges Williams.

8. Crown

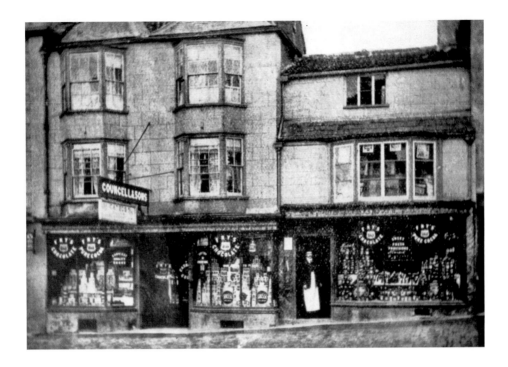

The Crown was situated in the High Street on the site now occupied by M&Co store. The earliest reference to the inn is in 1732, when it was held in trust by Richard Hawksworth for the benefit of the Free School, the rent being £4 per year. The property was then described as having stables, outhouses, garden and offices in addition to the main building. As a brewhouse is not mentioned, it can be assumed that the Crown bought in its beer from commercial brewers. The numerous outhouses attached to this inn, along with a large yard and access lane from St Mary Street, remained until being demolished preceding the construction of St Mary's Way shopping precinct. The above photograph shows the Crown building after it had ceased trading, when it had become a grocery and provision store.

This inn had a minor change of name in the late eighteenth century. When John Lippiatt was licensee between 1785 and 1789 it was known as the Crown, but a document dated 1790 — when his widow, Elizabeth, was licensee — refers to it as the Rose and Crown. All subsequent documents revert to calling it the Crown.

This was the inn where the conspirators involved in a local poaching affray in 1831 met to plan their mission, which resulted in a gamekeeper being shot dead near to Park Mill Farm.

The Crown closed in 1858, the licence was transferred to the Porter Stores and the last licensee moved to the Beaufort (second location).

See also Crookhorne in Unlocated Pubs, chapter three.

This photograph, taken from the High Street after the Crown building was demolished, shows the pub's cellar, with the ramps each side of the steps to allow barrels to be lowered and raised. This cellar is now buried under the shopping precinct.

This brass tobacco dispenser once stood on the bar of the Crown Inn. It measures nine and a half inches long, four and three quarter inches wide and four inches deep and is divided into two compartments. The smaller end houses a mechanism so that when an old half penny was inserted in the slot and the plunger depressed, the lid of the larger end sprung open to allow a plug or twist of tobacco to be removed. What type of tobacco or the amount is not known. The smaller end lid is secured by a screw lock, and to prevent theft of the box itself one of the four feet fitted into a socket on the bar. The engraving on the larger end lid reads 'Thomas Lane, Crown Commercial Hotel Thornbury'.

9. White Hart (First Location) Formerly Antelope

The National Westminster bank on the Plain occupies the site where this inn once stood. The earliest record of the Antelope is found in a tithe survey of 1696, the name in all probability coming from one of the emblems on the coats of arms of the Duke of Buckingham. In these early years, the Antelope was owned by a Quaker family, the Thayers, who lived at Kyneton House. By 1755, the name had changed to White Hart, probably in recognition of the Staffords being the new lords of the manor.

That year, a mortgage document describes the White Hart as a 'messuage or dwelling house with outhouses, stables, garden, paddock and summer house', the amount of the mortgage being £182 11s 9d. No mention is made of a brewhouse, which signifies that this inn also bought in its ale from commercial or common brewers.

In 1835, a weights and measures inspector visited Thornbury and on 17 April found that the licensee of the White Hart, Charles Jones, had three defective measures in his bar. A subsequent visit on 21 April found that he was still using defective measures. Charles Jones appeared at the petty sessions held at the Swan on 9 May, was fined 5s with 8s and 6d costs for the first offence and the same amount for the second. He also forfeited his measures.

The White Hart made the news in November 1850 when the *Bristol Mercury* reported an incident, which happened in the tap room of the pub, under the heading 'Manslaughter at Thornbury'. This referred to an argument between a local man and a visitor to the town, which resulted in the death of one and the imprisonment of the other. A full account of the event is given in Appendix 5.

By 1857, the inn was closed and awaiting demolition, the name and licence being transferred to premises in Castle Street. Today, the summer house near the entrance to Castle Court car park is the only remnant of the old inn.

10. Black Lion Formerly White Hart (Second Location)

This inn was on the site of the present-day Lion House at No. 9 Castle Street. In 1841, the property consisted of house, stable, coach house and garden — all owned by Thomas Fewster. By 1852, his son, George Fewster, was operating there as a wine merchant and that year sold it to Charles Prewett who, by 1855, had transferred his carrier business there from the White Hart on the Plain. This carrier ran daily return trips to the Full Moon in Stokes Croft, Bristol, which was the terminus for most of the carriers north of Bristol. Charles Prewett transferred the name and licence from the previous White Hart to this new location in 1857 and continued as a beerhouse keeper and carrier until 1862. That year, Harris Collings bought the property and renamed the pub the Black Lion. When he died in 1871 his widow, Harriett, inherited it and remained the licensee until the pub closed on her death in 1882. Another reason for its permanent closure is probably due to the 1880s being a period when the country was going through an economic recession, with the inevitable drop in trade for pubs and no one willing to take the business on. The building itself must have been in a poor state as the following year it was bought by a veterinary surgeon who demolished it and built the present Lion House.

11. Cockmead Formerly Apple Tree

This pub building in Kington Lane is still standing and is now a private residence known as The Hollow. It was used by drovers taking animals to and from Thornbury market, the cattle being penned in the narrow roadside field to the west of the building.

Its previous name suggests it started as a cider house, the date and reason for the change are not known. The last recorded licensee was Mary Ann Thurston who also carried on a business as a laundress from the premises. The Cockmead had ceased trading by 1869, the licence having been transferred to the Bathin Place.

12. Lamb (First Location)

This is another inn of which no physical evidence exists today, its location being determined from evidence in two different documents.

Firstly, the Thornbury rent roll of 1670 names a 'brue house' on the west side of the High Street between the old grammar school and the castle, near the parish boundary stone, the area where the present-day Warwick Place is situated. (Castle Street was, until about 1850, an extension of the High Street). The proximity of this brue house to the church may indicate that it could possibly date as far back as the twelfth century, when brewing was done on a communal basis, usually under the control of the church.

Secondly, the will of Kingsmill Grove, written in 1811, describes his residence as being built on the site of the Lamb. This residence was later known as Thornbury House, which, in turn, was demolished to make way for Warwick Place.

So, the Lamb could probably have been the first inn in Thornbury. The name could be derived either from its location and possible ecclesiastical connection, being named after the Lamb of God, or in recognition of the wool trade carried on in the district. When this inn was demolished some time prior to 1811, the name was transferred to other premises in the High Street.

One document that does exist concerning the Lamb states that in 1756 it was owned by the trustees of the Grammar School and rented to a Mrs Longman for £5 a year. That same year, repairs to the building had cost £12 6s 11d, so it must have been in a somewhat dilapidated state. Three years later, in 1759, it was rented to John Longman, presumably Mrs Longman's son, for £5 10s 0d a year. The conditions of the lease he signed would today seem somewhat harsh. The lease was to run for fourteen years, with the tenant unable to leave until after seven years and then only after giving six months notice. He must pay the window tax in addition to the rent. If the rent was not paid on the date due, and was still outstanding twenty-eight days later, the premises could be entered and goods and chattels taken to the value of the amount due.

13. Seven Stars

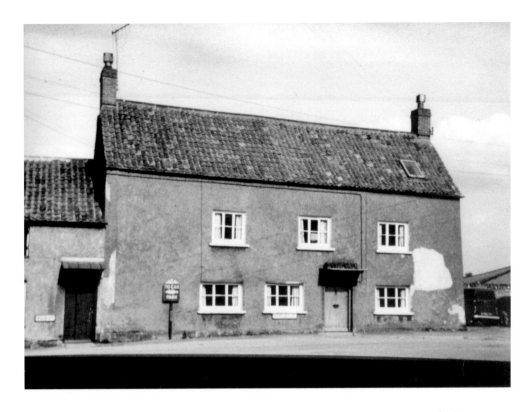

This rather imposing building, demolished in the 1970s, as part of the town's redevelopment, faced along Chapel Street and stood on what is now the forecourt of the police station. When this beerhouse first started trading is not known, possibly as a result of the 1830 Beerhouse Act, the name Seven Stars being transferred to it sometime before 1841, from the beerhouse that was on the site of the Plough. It was last recorded as still trading in 1884, when the licensee, Elizabeth Craddock, was charged for allowing drunkenness on the premises. A document of 1886 states that the 'former beerhouse known as the Seven Stars' was to be sold by auction, so closure occurred during the intervening period which coincided with the time of a sharp decline in the country's economy which forced many marginally viable pubs out of business. The sales document stated that the premises included stables, brewhouse and pig sties which indicate that at some time the Seven Stars brewed its own beer. An early licensee Thomas Bevan had a second occupation as a pig dealer and probably indulged in the practice of feeding the residue from brewing to his pigs.

After closure, the building was, for many years, a common lodging house. In the 1950s, there were still some pigsties at the rear of the building and as by then there was no other access to the back of the property, the pigs had to be driven in and out via the front door.

14. Horseshoe

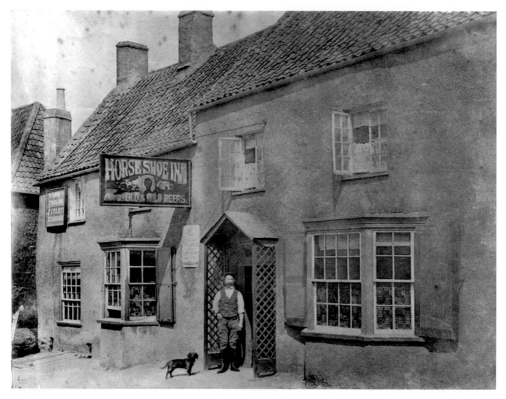

A surviving remnant of the Horseshoe Inn is the glass panel from over the door. This is now in the archives of Thornbury Museum. Note the spelling.

This inn was situated on the corner of Horseshoe Lane and St Mary Street in the building now occupied by the Charcoal Grill and Giggs' hair stylist. There is a reference in the *Register of Inns in the County of Gloucestershire* to a Horseshoe Inn being in existence in Thornbury in 1755, but no information as to its exact location. In 1840, the present building was a grocer's shop, which may have had a beer licence, as many did, to provide extra income.

During the latter part of the nineteenth century, between 1858 and 1894, four members of the Wilson family held the licence, one of whom, Thomas Wilson, is of interest. In 1861, two years before he took over from his brother, Ephraim, he was noted on the census as being a Chelsea pensioner at the age of thirty. At that time, Chelsea was a true hospital for wounded soldiers, not a retirement home as it is today. It transpires that Thomas Wilson, who was born in Thornbury, joined the army in 1848 and served in the Crimean war as a sergeant in the Royal Artillery. He was present in the siege of Sebastopol and was decorated by the Turks. Then, in early 1856, he was

kicked by a horse on his right ankle. This injury brought him back to England and, after hospitalisation, he was discharged in 1859 with a permanent limp, which rendered him unfit for further military service. He received a pension of 10*d* per day.

This inn had been a tied house since at least 1887, with the beer supplied by R. W. Miller & Co. from their Stokes Croft brewery in Bristol. In 1900, the Horseshoe was offering 'good stabling and accommodation for cyclists'.

The 1904 Licensing Act gave magistrates the power to close licensed premises that they deemed in excess of requirements for their area. At the 1905 Brewsters Sessions, when the police gave their annual report on the state of licensed premises, the Horseshow was one of two beerhouses in Thornbury recommended for closure. The reason given was that it was only yards away from another beerhouse, the Porter Stores. What was not mentioned and may have influenced their choice was that, over the preceding years, several drunks had been apprehended in St Mary Street and Horseshoe Lane, who may have been imbibing in the Horseshoe. Being drunk in a public place was not a punishable offence until after the 1902 Licensing Act. The magistrates decided in 1906 that the Horseshoe was to close but provisionally renewed its licence until the amount of compensation was fixed. The Horseshoe finally closed on 13 March 1907, since then the building has housed a hardware store and a betting shop before taking its present usage.

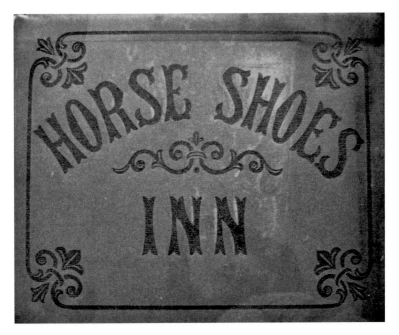

This glass door panel is now in the archives of Thornbury Museum. Note the spelling.

15. Star

What is now a private residence at No. 15 St John Street was once a beerhouse known as the Star. The building, with its distinctive roof style, may possibly have been a malt house before becoming a beerhouse in the 1800s.

The proprietor of the Star in 1840 was sixty-two-year-old Luke Withers, who owned several other properties in the town, so unlike other beer-house keepers, he did not need a second occupation. His next door neighbour, Mark Smith, who lived in what is now No. 13 St John Street, was shown in the 1841 census to be a shoemaker but must have helped out as barman in the Star as by 1858 he was sufficiently capable in the trade to become the first licensee of the Plough. In 1858, Luke Withers would have been eighty years old, so he obviously surrendered the licence of the Star, which was transferred to the Plough along with his neighbour.

16. Crispin

This inn was in what is now Crispin House in Crispin Lane and is believed to have originated around 1830 as one of the two guinea beerhouses in the town. The front of the building dates from the early 1800s and was joined to what remained of an earlier seventeenth-century building at the rear.

The name Crispin, or Jolly Crispin as it was sometimes called, was in recognition of the boot and shoe makers who were concentrated in the St John Street/Pullins Green area of Thornbury in bygone years, St Crispin being the patron saint of shoemakers. The earliest occupier of the original property, in 1683, John French, is also recorded as being a shoemaker. In 1838, the Crispin was owned by Luke Withers, who also owned the Star in St John Street, the tenant being James Cullimore. When Luke Withers died, in 1867, he willed the ownership of the Crispin to the sitting tenant, Hester Cullimore, the widow of James Cullimore, and it was to remain in the Cullimore family as a free house until it closed in 1902.

Today's Crispin Lane was previously known as Mutton Lane and, for a short while, as Blakes Avenue, and it only took its present name when the inn closed.

Unlocated Pubs

Bell

A Bell Inn is known to have existed in Thornbury from the following two entries in the parish burial register:

> 26th March 1770 Amy, wife of Joseph Saunders, publican, died aged 30
> 2nd July 1775 Joseph Saunders of the Bell, died of smallpox

The area where Gloucester Road and Quaker Lane meet The Plain is believed to have once been known as Bells Cross, so, on this assumption, the Bell Inn could have been the forerunner of the Boar's Head/Royal George. However, in early times, a cross did not refer to a road junction but to an obelisk or column with a cross on the top, which was used by evangelists as a gathering point to preach the word of the Lord. The road junction would not have been an ideal location for this, so the cross may have been some yards to the west on a wider part of The Plain. This brings into consideration Nos 10 and 11 (now occupied by an estate agent and osteopath), which are known to have been built in 1790 on the site of a previous inn. So, the Bell Inn could have been on the site of the Royal George or Nos 10 and 11 The Plain.

Crookhorne

The Crookhorne is identified as being as inn in *Gloucestershire Place Names*, vol. 3, by A. H. Smith, and is again mentioned in the will of a John White, dated 1590. There, it is stated as being near the market hall (now Wildings). This brings two possible sites into consideration. As it has been found that inns tended to be built on sites previously associated with the trade, the Crookhorne could have been the forerunner of either the Crown or the White Lion.

Heronceau

This was, again, identified as being an inn in *Gloucestershire Place Names*, vol. 3, by A. H. Smith, which gives a date of 1474 for its existence. No further information is available to determine its location.

Horse and Jockey

The only reference to this inn is in *Caffells Local History vol. III*, where it states:

> On 13th September 1735 Edward Bingley of Thornbury, living at the sign of the Horse and Jockey entered into recognizance of £20 with two sureties of £10 apiece to keep a common alehouse and victualling house wherin he now dwelleth for one whole year according to the statute.

This must have been a well-established alehouse as it also provided food, and, knowing that the names of alehouses frequently changed with a change of owner, this pub could possibly be the forerunner of any number of inns in the town, the most likely being the White Lion.

Mermaid

There is an old document (GRO D9400/4/3/2) stating that a Court of Session was held at the Mermaid in Thornbury in 1687 to determine who amongst the local land owners was responsible for repairing and maintaining the sea walls, grouts and waterways adjoining the river Severn. This is the only document that mentions the Mermaid and no evidence exists as to its location. It could be an early name for one of the longer established inns.

Unnamed Brewhouse

An entry in *Caffells Local History*, Part III, states the following:

> 1594, unidentified brewhouse owned by Katherine Rippe bequeathed to Elizabeth Moore, also corner house and backside adjoining brewhouse to become an almshouse.

The location of this brewhouse cannot be determined with any accuracy, but as the early almshouses were in the lower part of St Mary Street (now Quaker Lane) the brewhouse was possibly in that area.

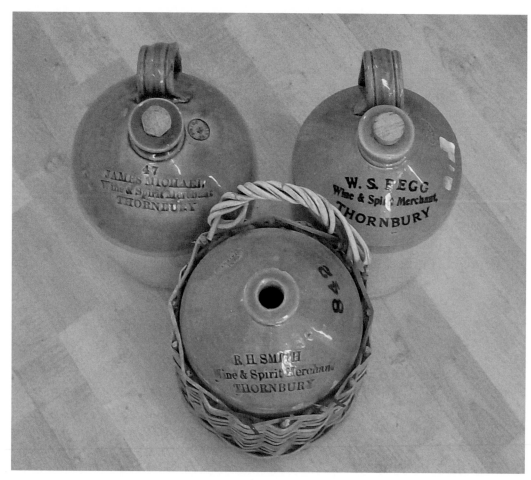

These one gallon earthenware jars were used by dealers to supply their customers with wines and spirits. Top left: Jones Michael who operated from his premises from 1885 to 1892. Top right: W. S. Pegg at the Swan 1906 to 1919. Centre: R. H. Smith at the Exchange 1892 to 1920.

FOUR

OTHER OUTLETS

Two Guinea Beerhouses

The two guinea beerhouses came into existence as a result of the 1830 Beerhouse Act, when anyone of good character could open a beerhouse upon payment of the licence fee. As well as allowing new outlets to open, it also permitted previously unlicensed beerhouses to become legal by paying the fee. After the 1830 Act, there were, besides the five inns (Beaufort, Crown, Lamb, Swan and White Hart), an unknown number of beerhouses in Thornbury, this being due to no records being available. The majority of the town's pubs, both past and present, can, however, trace their origins as beerhouses to this period, they are:

Bygone pubs	Cockmead, Crispin, Horseshoe, Seven Stars and Star
Present Day pubs	Anchor, Black Horse, Royal George, Wheatsheaf, White Lion
	(The Barrel, Knot of Rope and Plough came into being as a result of licence transfers after 1830)

To curb the increase in the number of beerhouses being opened, the licence was raised to three guineas in 1834, and in 1840, the rateable value of the premises had to be at least £8. These increases reduced the number of outlets and restricted most others to being in the hands of owner/occupiers. Some of the beerhouses that did not survive to become pubs and were only open for a few years have been traced to:

No. 61 High Street
No. 15 The Plain
No. 21 St John Street
No. 30 Castle Street

Today, the large number of outlets available for beer sales may seem excessive when, according to the 1841 census, the adult population of Thornbury was 1,862. But Thornbury was then only a typical market town.

Bathin Place

The Bathings elderly persons home at the bottom of Bath Road is roughly on the site of, and takes its name from, what was once a public wash place. This washing facility, known as the Bathin Place, came into existence sometime in the first half of the nineteenth century, when personal hygiene became known to be a factor in combating many diseases and illnesses. Communities were initially encouraged to provide facilities for their inhabitants to wash, but it later became a legal requirement as a result of the Baths and Washhouse Act of 1846. The borough of Thornbury, however, had responded to the initial recommendations and the Bathin Place was a functioning

concern by 1840. The water supply to it came from a surface stream, which originated at Vilner hill.

The construction of the railway to Thornbury, which began in 1868, was, in those days, a very labour intensive undertaking, and the facilities at the Bathin Place were very much in demand by many navvies and engineers. As an added incentive to his new customers, the owner of the Bathin Place, George Excell, obtained the beer licence from the Cockmead when that pub ceased trading in 1869. This was only a short-term arrangement as by 1874 beer sales at this site had ceased.

The need for public washing baths diminished when a piped water supply was provided to the town. The Bathings, as it became known, was then adapted to provide a small open-air swimming pool, which eventually closed in the 1950s after an outbreak of polio, and the whole site was later demolished as part of the town's expansion.

Essential tools for drinking at home. These were supplied by brewers and distillers to their outlets for onward distribution.

Pretty House

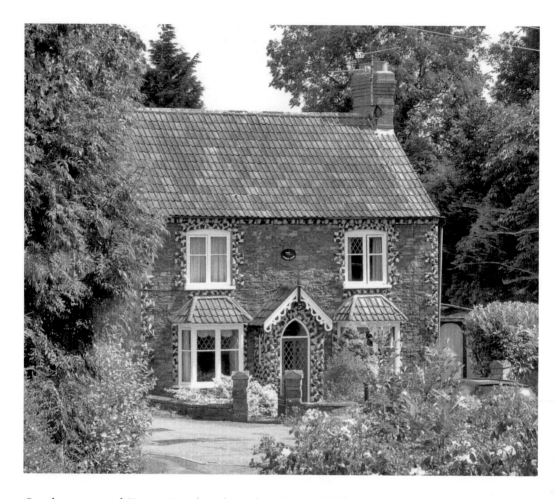

On the corner of Knapp Road and Hackett Lane stands a property now known as Cannon House, but to the older generation of locals it has always been known as the Pretty House due to its fancy stonework. In the early years of the 1900s, the owner obtained a licence to sell beer, which coincided roughly with the time the Crispin surrendered its licence. The terms of this licence were, however, a bit of an oddity, the premises being classed as an outdoor on licence, which meant the beer was sold from the house but had to be consumed within the grounds. Although licensed as a beerhouse, the main drink sold was cider, and the customers could often be seen perched on the rear garden wall. This must have been Thornbury's first beer garden.

The Pretty House continued its outdoor trade till it closed in the 1940s.

Off Licences

Michael's

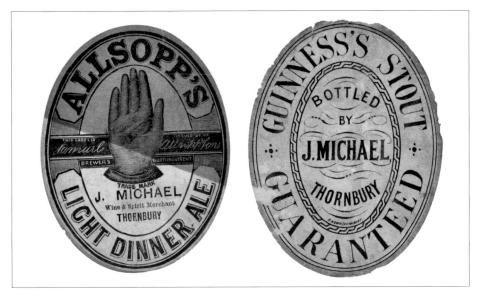

Labels from Michaels Bottling Plant.

The drinks trade was using part of the buildings of today's Knot of Rope for some time before it became an inn. The earliest record dates from 1849, when James Michael, who was a wine and spirit merchant, occupied the right-hand or southerly of the three original buildings of the inn, having taken over the business from Sam Lovegrove some years previously. This was an L-shaped property of mid-seventeenth-century origins, with a rear wing, which extended to Chapel Street, containing a yard and stable.

In 1871, his widow and son, James Merrett Michael, were running the business. J. M. Michael was listed as an ale and porter dealer, while his mother, Ann, dealt with the wines and spirits. Business must have been profitable, as by this time they had become owners of the property — having previously been tenants — and had also expanded into the adjacent property, which is the central part of today's inn.

The opening of the railway to Thornbury in 1872 allowed beer to be brought to the town from further afield and J. M. Michael to expand his business. He now opened a bottling plant in his extensive outbuildings, for beers such as Guinness and Allsopps light ale, which he sold through his off licence, thus giving the townsfolk of Thornbury a wider choice for home consumption than was previously available.

In 1889, J. M. Michael obtained an on licence when the nearby Beaufort Arms closed. He opened his premises as a full licensed public house. As his previous business had been known as Michael's, he kept this name for the new inn, thus making it the only pub in Thornbury to bear the owner's name.

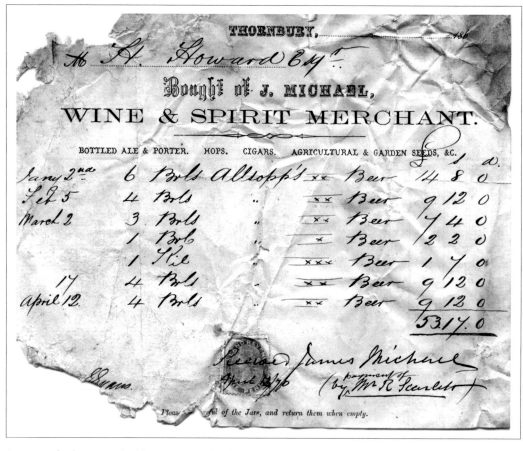

A receipt for beer supplied by James Michael to Henry Howard of Thornbury Castle that shows the wholesale price of beer in the 1870s.

 1 barrel (36 gall) of X beer cost £2..2..0 (£2.10p)

 1 barrel (36 gall) of XX beer cost £2..8..0 (£2.40p)

 1 kilderkin (18 gall) of XXX beer cost £1..7..0 (£1.35p)

The beer was presumably for the castle staff as a supplement to their wages, a practice that ceased when Sir Stafford Howard, a leading Temperance advocate, took up residence.

Ansteys

Market Street, Thornbury.

In 1887, Thomas Anstey inherited a glass and china shop at what is now No. 24 High Street from his aunt, Elizabeth Ford. This shop has parts dating from the sixteenth century but was rebuilt in the mid to late eighteenth century, with the distinctive cast iron Gothic-style balustrade over the shop windows added at a later date. By 1891, Thomas Anstey had changed the usage of this shop to a wine and spirit merchants and, being in a more central part of the High Street, was able to entice business away from J. M. Michael's further up the street. This became the main off licence in Thornbury and was subsequently owned by Grantley Huggins and Victoria Wines before it ceased trading in the early 1980s, when Victoria Wines moved next door to No. 26. The new and present occupants, Heritage, sell a line of goods that are, in many ways, the modern equivalent to those sold in the original shop.

Sibland House

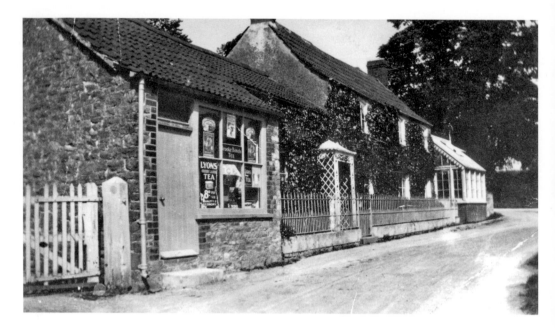

Now a private residence, Sibland House, on the corner where Sibland Way joins Sibland Road, was, for many years, a general stores. It served the cottages and farms in its immediate area, and, as such, like other similar businesses, it was the forerunner of today's convenience stores. When it obtained an off licence is not known, but it sold bottled beer up to the 1940s, which is when the stores closed.

Another outlet for beer in this vicinity was the premises of John Goodman, whose actual location is somewhat vague. The County directory for 1874 lists him as being a beer retailer and farmer at Crossways, while the 1871 census records him as a farmer at the Hackett.

APPENDICES

Appendix One

The following is a transcript of document GRO D2438/1 authorising James Vaughan of the Swan to act as excise agent for the town of Thornbury:

O All to Whom these Presents shall come, greetings know ye that we whose names are here unto set, and seal affixed, being the major part of the chief Commissioners and Governors for the Management of the Receipt of EXCISE, and other duties put under our Management and Receipt; in pursuance of the powers and authorities to us given have constituted, deputed, and appointed, and by these presents do constitute, depute and appoint James Vaughan to be our Deputy-Agent and Officer, for keeping of the Office of Excise at the sign of The Swan in the Town of Thornbury within the County of Gloucester and for the receiving of all entries to be made by all common brewers, distillers, rectifiers, victuallers, inn-keepers, ale-house keepers and other sellers and retailers of beer, ale, cider, and perry, sweets, and of all other exciseable liquors, makers of vinegar, mum, sweets, metheglin, and mead for sale; and also by all maltsters and makers of malt, hop planters, and by all makers of candles, sope, starch, paper, paste-board, mill-board, and scale-board; and by all printers, painters and stainers of paper and by all printers, painters and stainers of silks, calicoes, linens and stuffs; tanners, tawers, curriers, and dressers of hides and skins, and pieces of hides and skins, makers of bricks and tiles; and by all dealers in, or sellers of wine, by wholesale or retails: And all other personal and persons, chargeable, or to be chargeable with any duties which now are, or hereafter may be under our receipt or management or under the receipt and management of the Commissioners of Excise for the time being; and for the receiving of the duties on the commodities aforesaid; and for performing of all other matters and things touching the said duties, according to the several Acts of Parliament relating to the same: This our Commission to continue and be in force, during the pleasure of us the said Commissioners, or the major part of us, or the Commissioners of Excise for the said duties or the major part of them for the time being. In Witness whereof, we have hereunto set our hands and seals the twenty seventh day of April in the thirty sixth year of the Reign of our Sovereign Lord GEORGE the THIRD, by the Grace of God of Great Britain, France and Ireland, King, Defender of the Faith and so forth, and in the year of Our Lord on thousand seven hundred and ninety six.

Appendix Two

The second and in some cases primary occupations of licencees in Thornbury between 1841 and 1923. This information has been taken from census reports and trade directories. Information of this nature is lacking prior to 1841.

ANCHOR	Henry Honeybourne	1870 – 1876	pork butcher and grocer
	Thomas Honeybourne	1876 – 1919	butcher
BEAUFORT (2nd)	Edward Luce	1871 – 1876	auctioneer
BLACK HORSE	William Cullimore	1861 – 1871	carpenter
BLACK LION	Charles Prewett	1852 – 1861	bus owner and carrier
COCKMEAD	Mary Thurston	1851 – 1871	laundress
HORESHOE	Ephraim Wilson	1858 – 1861	potato dealer
	Thomas Wilson	1871 – 1882	grocer
LAMB	Thomas Bevan	1851 – 1861	pig dealer
PLOUGH	Mark Smith	1858 – 1861	shoemaker
PORTER STORES	Thomas Pointing	1870 – 1891	hay and straw dealer
	Thomas Brown	1891 – 1898	blacksmith
	James Ford	1911 – 1918	carrier
QUEENS HEAD	Hugh Smart	1858 – 1888	grocer
	William Underhill	1889 – 1902	carrier
ROYAL GEORGE	George Phipps	1881 – 1885	blacksmith
	Samuel Phipps	1918 – 1923	carrier
WHEATSHEAF	John Williams	1841 – 1858	brewer
	Alfred Pointing	1871 – 1876	baker
	Alfred Stinchcombe	1880 – 1891	coal merchant
	John Phillips	1891 – 1892	painter

Appendix Three

Beer suppliers to the Thornbury pubs during the latter part of the nineteenth century and early part of the twentieth century.

Anglo Bavarian Brewery, Shepton Mallett	Swan
Arnold & Co., Wickwar	Porter Stores White Lion
Ashton Gate Brewery, Bristol	Exchange
R. W. Miller & Co. Stokes Croft Brewery, Bristol	Queens Head Horseshoe
Perretts Brewery Bournestream, Wotton under Edge	Anchor
G. Playne & Co. Forwood Brewery, Minchinhampton	Black Horse Wheatsheaf
W. J. Rogers Ltd Jacob Street, Bristol	Royal George
Daniel Sykes & Co. Redcliff Brewery, Bristol	Plough

Appendix Four

The saga of the correct sign for the Royal George was deemed to be of such importance that it was front-page news in the local *Gazette* in early 2004. Research has found that the pub was called the Boars Head up to 1875 and took its present name from that date, when a change of ownership occurred. There is no documentary evidence to explain the reason why the new owner, James Knapp, changed the name, so it can be assumed that he did it to commemorate some event in his life. So who was he?

What is known of James Knapp is that he was born in Shepperdine in 1824, and he appears in the 1861 census as living in Cardiff with his wife, Martha, and daughter, Emma, his stated occupation then being that of pilot. He does not appear in the 1871 census, probably being away at sea. He then later returned to his native area and bought the Boars Head in 1875. He died sometime between 1875 and 1881, as the census for that year shows his widow, Martha, living in Shepperdine. The exact year of his death cannot be determined, as burial records for Oldbury were lost in the church fire of 1897. The maritime connection has been established by his occupation, but did James Knapp serve on the Royal George?

The warship *Royal George* can be ruled out, as that vessel was accidentally sunk off Spithead in 1782. Two subsequent naval vessels called *Royal George* can also be disregarded, as their time in service was also before James Knapp was born. One was a corvette launched in Canada in 1809 and renamed *Niagara* in 1814, the other was a royal yacht launched in 1817 and which had become a hulk by 1842. There was, however, another *Royal George* afloat between 1828 and 1853, this being a commercial vessel carrying emigrants from England to Australia. If this is the vessel that James Knapp served on at some time in his career, the white ensign and gun ports on the pub sign on page 40 were incorrect.

A photograph of the pub with a ship sign taken in the late 1970s is not clear enough to show precise detail.

Appendix Five

Manslaughter at Thornbury

An account of the above incident, which occurred in the tap room of the White Hart, was published in the *Bristol Mercury and Western Counties Advertiser* on Saturday 30 November 1850, the actual event having taken place on 24 November the previous Sunday. The two main people involved were:

The deceased	Anthony Craddock, aged sixty-five. A native of Yorkshire, employed by a company examining the mining capabilities at Alveston and Tytherington. He was said to be a clever and useful man and held a superior position in his company. When sober he was a quiet, civil man but occasionally he yielded to intemperance.
The accused	John Pegler, aged twenty-eight. A native of Thornbury, employed in the town as a baker for fifteen years. He was described as being 5 feet 3 inches tall, with round shoulders.

The sequence of events were as follows:

Both the deceased and the accused had been in the tap room around 5 p.m. on the Sunday, when all was quiet and peaceful. About 8.30 p.m., a Miss Gunter, daughter of the licencee, called out to police sergeant William Taylor, who was passing, to tell him there was a drunken man inside and ask him to go in. At the same time, Pegler was returning to the tap room from the inn stables. When Pegler entered the tap room, where there were six or seven other persons, he made his way towards the fire. As he did so, Craddock, who was seated, put out his hand and pushed Pegler back saying 'Get back you b....y thief, are you going to rob me.' Pegler stood back and said 'What dy'ye think I want to rob thee for' then struck Craddock two blows to the left side of his head. Craddock then fell to the floor on his hands and knees and did not speak after he was struck. The police sergeant was entering the room at this time and witnessed the blows being struck; he grabbed Pegler's arm to prevent any further blows (he later testified that the blows were struck quickly and, in his opinion, were not very violent). The sergeant then attempted to lift Craddock up but as he was a dead weight let him fall and told those present 'better let him lie for a few minutes and he'll revive again'. Craddock had been frequently seen in an intoxicated state by the sergeant. He then left the inn and returned to the police station.

A few minutes later, a man arrived at the police station to inform the sergeant that Craddock was dead. 'Yes, dead drunk' replied the sergeant, not believing him, but he was then told that a doctor had been sent for. The doctor, F. Jones Esq, arrived at the White Hart about 9.00 p.m. and confirmed that Craddock was dead. Pegler was

immediately apprehended and taken before a magistrate the following morning, when he was remanded until Wednesday 27 November, when the inquest was held.

At the inquest, the doctor's post mortem stated that there were no external marks of violence on the trunk of the body and internally there was every evidence that Craddock was a remarkably healthy man. There was, however, a slight cut adjacent to the left eye, two abrasions to the nose and discolouration around the left eye, but those did not appear to be recent. There was no fracture of the skull but a quantity of extravasated blood was found at the base of the skull, which had penetrated the spinal column causing instantaneous death. This might have been caused as a result of blows or a fall while the deceased was in an intoxicated state. The jury returned a verdict of manslaughter against Pegler and committed him to trial at the next Gloucester assize. Pegler was admitted to Gloucester Gaol the following day.

The reports of assize court trials for this period have not survived and no information can be found in Gloucester Records Office or the national archives at Kew. What is known is that the Gloucester Gaol log shows that Pegler went to the assize court in Gloucester on 28 May 1851 charged with feloniously and unlawfully killing Anthony Craddock to which he pleaded guilty. He was sentenced to be imprisoned in a common gaol for two calendar months, and, as he had been in prison since the previous November, he was released the same day. This sentence seems surprisingly light for a charge of manslaughter, leaving the reasons open to conjecture.

The cuts and bruising to Craddocks face, which were the result of some blows received some time prior to his death, may have caused the blood to accumulate at the base of his skull, and the movement of his head during the scuffle in the White Hart enabled the blood to enter his spinal column. So, at what stage during the scuffle did this blood enter his spinal column? Was it a result of:
a) the blows he received to his head,
b) him falling forward onto his hands and knees, or
c) being dropped on the floor by the police sergeant? It would appear that the jury could not be certain what movement caused Craddock's death, so Pegler was given the benefit of the doubt and his sentence of two months must have been the then tariff for the lesser offence of causing an affray.

Appendix Six

Sources of Information

Unless already stated in the text, the sources of information and illustrations are as follows:

	TEXT	ILLUSTRATIONS
Front Cover		TM
Frontispiece		Author
		page 8, C. Doig
CHAPTER ONE		
The Early Years	Bibliography 4, 5 & 6	
	Farleys Bristol Journal 1776	
Brewing		page 12, C. Doig
		page 14, TM 48/P
Government Legislation	Bibliography 1&2	
Arrival of the Railway		page 16 TM
A Family Business	GRO D4764/3/8	
	GRO PS/TH	
Late Victorian Era	Bibliography 2	page 18, Author
		page 18, Author
Not Only Beer Sales	GRO D4764/3/8	
Cider		page 23, Author
		page 26, GRO
CHAPTER TWO		
Anchor		page 28 TM/533/P
		page 29 T. Edgell
Barrel		page 30 TM
		page 31 Author
Black Horse	Blbiography 3	page 33 TM
		page 34 TM
Knot of Rope		page 35 TM
		page 36 TM
Plough	Bibliography 3	page 37 TM
	GRO D3412/3	page 38 Author
Royal George		page 39 TM 583/P
		page 40 Gazette
Swan	GRO D108 E5	page 41 TM
	GROD108M130	page 43 B. Baylis
		page 43 TM
		page 44 Author
Wheatsheaf	GRO D8947	page 45 R. Powell

GLOSSARY

Bottle and jug	A small compartment in a pub with direct access to the bar from outside, separated from the other public rooms. This was the only part of licensed premises to which minors were allowed entry.
Burgage	An area of land, usually freehold, consisting of a house or houses with garden and attached land. Derived from an ancient form of tenure, with the payment of rent to the local lord of the manor in lieu of the occupant giving his labour or other services to the manor.
Carrier	Person whose four-wheeled horse-drawn van was used to convey agricultural produce from rural to urban areas, returning with goods for shops and individuals. A limited number of passengers could also be carried.
Currier	Person who transforms cow hides to leather.
Double Licence	An early term for fully licensed premises denoting that it was licensed for both beer and wines and spirits.
Extravasted Blood	Blood that has leaked from a vessel into the surrounding tissue.
Free House	An inn where owner is free to enter into a contract with any brewer of his choosing to supply beer, wine and spirits. Opposite of a tied house.
Fully Licensed	An inn which is licensed to sell beer, wines and spirits.
Guinea	an old unit of currency equivalent to £1..1..0 (£1.05)
GRO	Gloucester Records Office.
Hogshead	54 gallons

Messuage	Portion of land used as a site for a dwelling house.
Metheglin	A spiced variation of mead when cloves, ginger, rosemary or thyme has been added to the fermentation process.
Mum	Short for chrysanthemum, whose aromatic leaves were used in medicines in the past.
Off Licence	An establishment where the drinks purchased must be consumed off the premises.
On Licence	An establishment where the drinks purchased may be consumed on or off the premises.
Porter	A drink darker in colour than ale but lighter than stout. Its colouring was obtained by varying the amount of malt in the brewing process after the grain had been subjected to a high heat sufficient to scorch or blacken it. This drink was a favourite of the porters at Smithfield market in London, hence its name. Arthur Guinness took the porter brewing process to Dublin, altered the procedure and produced the drink, which bears his name.
Spile	A small round truncated cone of soft wood about two inches long and half an inch diameter at its largest end. This was knocked lightly into the top of the barrel and used to manually regulate the flow of air into the barrel.
Tawer	Person who dresses and prepares the skins of sheep and goats by the application of alum.
Tied House	An inn whose license is tied or restricted to sell only beer supplied by one brewer who is usually the owner of the inn.
TM	Thornbury Museum

INDEX